Working with Light-Sensitive Materials

First published in Australia in 1978
by Van Nostrand Reinhold Australia Pty Ltd
17 Queen Street, Mitcham, Victoria 3132
Van Nostrand Reinhold Company
135 West 50th Street, New York, N.Y. 10020
Van Nostrand Reinhold Ltd
1410 Birchmount Road, Scarborough, Ontario
Van Nostrand Reinhold Company Ltd
Molly Millar's Lane, Wokingham, Berkshire

© 1978 Van Nostrand Reinhold

Designed by Jenny Elliott
Typeset by Savage & Co, Brisbane
Printed in Hong Kong by Toppan Printing Co.

ISBN 0 442 25005 3

L/C # 78-55405

National Library of Australia
Cataloguing in Publication Data
Hindley, Geoffrey.
 Working with light-sensitive materials.
 Index.
 ISBN 0 442 25005 3.
 1. Photography. I. Title.

770

Working with Light-Sensitive Materials

Geoffrey Hindley

VAN NOSTRAND REINHOLD

Contents

Introduction

The book introduces, in simple terms, two areas which will be of interest to both the enthusiastic amateur and to the serious artist in Fine and Graphic Art. It takes a fresh look at photography with particular reference to what can be achieved with home-built cameras and photographic screen stencil printing. Photography and photographic screen printing are looked at together because of the unique quality they give when used and brought together.

Although the book is not intended as a complete guide to photography, all the processes of black and white film developing, printing and enlarging are clearly and adequately covered. It shows stage by stage how to progress from either a hand-drawn or photographic original to eventual reproduction as screen prints on paper or material. For those interested, the entire photographic and screen processes can be duplicated without resorting to proprietory packaged material.

Used educationally, the entire book is exciting and stimulating, and there are parts which can be used over a wide range of age and ability across several subject areas, notably art and science.

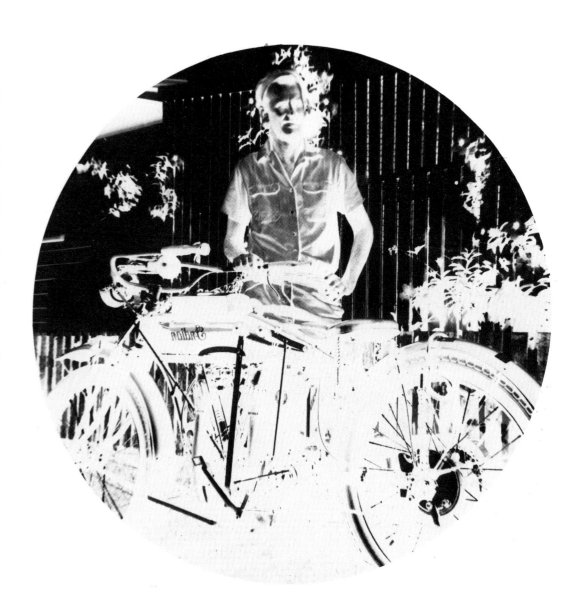

Acknowledgments

This book is dedicated to my family. Special thanks to Debbie Butler, Garry Bowtell and Simon Fox, who assisted me in the preparation of printing sequences, to T.F. who saw the need and urged me on, and to the publisher who realised the need. Thanks also to the many students over the years who asked how and why, and gave me a purpose.

Geoffrey Hindley

1

A Brief History of Photography

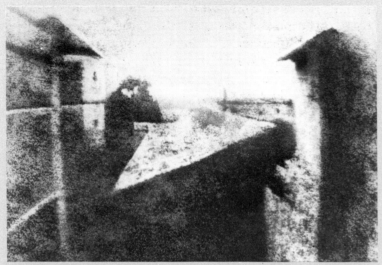

Joseph Niepce. *View from Window at Gras. 1826.*
Heliograph. Probably the world's first photograph.—Gernsheim Collection, Humanities Research Centre, University of Texas, Austin.

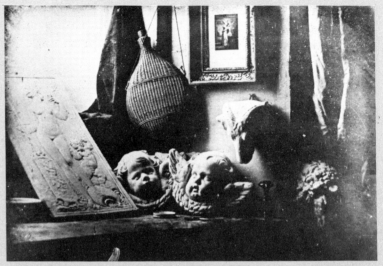

Louis Daguerre. *The Artist's Studio. 1837.*
Daguerreotype.—Societe Francaise de Photographie, Paris.

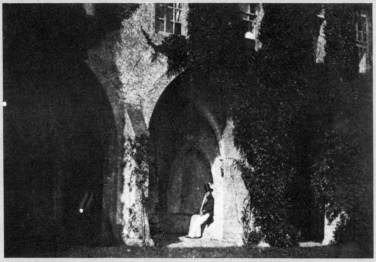

William Talbot. *Cloisters of Lacock Abbey.— George Eastman House*

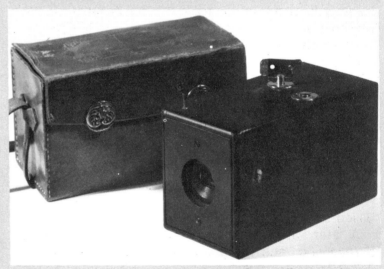

Kodak No. 1. *The original box camera—George Eastman House.*

The earliest references to the phenomenon of an outside image reproducing itself inside a darkened room originated around Persia and North Africa as early as the 10th century.

Leonardo da Vinci, in the 15th century, referred to his closing the wooden shutters of a room to find that the image outside was entering through a small hole in the wood and reproducing itself on the wall opposite. Moreover the scene was in full colour, had movement, was upside down and back to front. The situation is exactly the same that exists inside all cameras. You could say that Leonardo was standing inside a giant camera, hence the name 'Camera'. The Latin for darkened room is camera obscura.

If you have a darkroom where you process your photographic materials you can try all this out for yourself by drilling a hole between ¼'' and ⅜'' depending on the depth of the room, in one wall which faces a brightly lit scene and, providing the distance between the hole and the opposite interior wall is not too great you can observe for yourself the very basis of photography. Let the light fall upon a white surface.

Since first being discovered, the phenomenon has been developed as both a curiosity and as an aid to artists. The images were made to appear in a variety of ways from small portable canvas 'rooms' in which the occupant could stand, to boxes with a lens which threw an image onto a ground glass plate on which the artist would place a thin paper and trace the image with absolute accuracy. The Venetian painter Canaletto based some of his work on this method.

A later variation in the houses of the wealthy was a revolving lens fitted into a roof allowing a 360° image to be projected down onto a white table allowing the entire neighbourhood to be scanned in full moving colour. The presentations for these events were known as camera obscura or camera obscura if it could be seen on the rear wall of a camera.

How tantalising it must have been for a person who would have liked to have frozen the image in a camera obscura as in a painting and to preserve it somehow.

Here is a brief guide to its eventual preservation. With all brief guides many names of people who contributed in small ways have to be omitted, but these can be found in the many photographic histories published.

It does not include the development of the lens which ran parallel with the development of photographic paper and film.

1727 Johann Heinrich Schulze, a German physicist, discovered that images could be made, but not kept, by exposing silver salts to sunlight.

1826 Joseph Niépce, a French chemist, produced the world's first photograph by exposing a silvered plate in a box camera and using an etching process to preserve the image.

1839 Louis Daguerre, a French painter, first using silver iodide, then silver bromide-coated plates and developing with mercury vapours, finally preserved the images with table salt. After Talbot, this, together with his development of an improved glass-ground aperture opening, brought the exposure time down from minutes to seconds.

1839 William Talbot, a British scientist, developed light-sensitive paper coated with silver iodide and damped with silver nitrate and gallic acid before exposure. Table salt preserved the image by rendering the unexposed silver inert. This method produced a negative print from which numbers of positive prints could be made by contact printing. This principle is in use today. Sir John Herschel produced the name 'Photograph' defining it as the 'Art of obtaining images upon sensitized surfaces by the action of light'. He further assisted both Daguerre and Talbot by suggesting the use of sodium thiosulphate, or hypo, as a fixative. This is used today.

1847 Claude de St. Victor, French, experimenting to overcome the inherent graininess in paper negatives of the period, sharpened the image by using a mixture of potassium bromide and egg white coated on glass plates sensitised with silver nitrate.

1851 Frederick Scott Archer, a British sculptor, mixed collodion salts with gelatine. This enabled the light sensitive surface to dry so it could be more easily carried. Called 'dry plate'.

1874 Richard Kennet supplied dry plates to photographers.

1878 Charles Bennett produced dry plates coated with gelatine in which silver bromide grains were suspended. This is in general use today.

1888 George Eastman, American, while in business manufacturing dry plates, used a roll of paper instead of glass and sold this already fitted into a camera. The camera was returned to Eastman for processing into 100 mounted prints. The cameras were called 'Kodak'.

1889 Eastman used celluloid instead of paper for the base and produced, more or less, the photographic film as we know it today. This later contribution enabled home developing to flourish due to the relative ease of processing.

2 The Darkroom and Essentials

Working with Light-Sensitive Materials

Suggested darkroom layout.

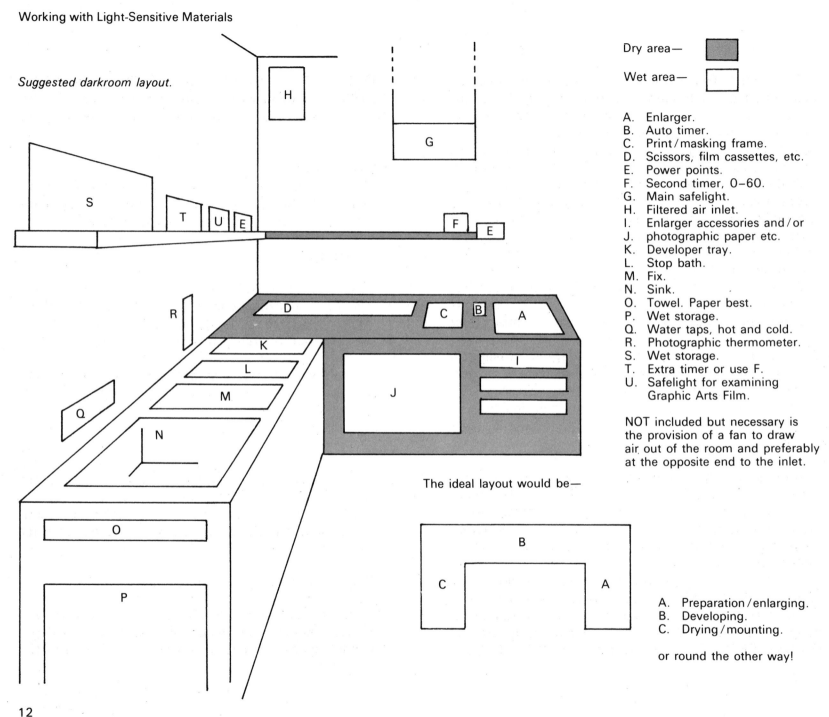

Dry area— ▓

Wet area— ☐

A. Enlarger.
B. Auto timer.
C. Print/masking frame.
D. Scissors, film cassettes, etc.
E. Power points.
F. Second timer, 0–60.
G. Main safelight.
H. Filtered air inlet.
I. Enlarger accessories and/or
J. photographic paper etc.
K. Developer tray.
L. Stop bath.
M. Fix.
N. Sink.
O. Towel. Paper best.
P. Wet storage.
Q. Water taps, hot and cold.
R. Photographic thermometer.
S. Wet storage.
T. Extra timer or use F.
U. Safelight for examining
 Graphic Arts Film.

NOT included but necessary is the provision of a fan to draw air out of the room and preferably at the opposite end to the inlet.

The ideal layout would be—

A. Preparation/enlarging.
B. Developing.
C. Drying/mounting.

or round the other way!

Darkroom? The name is not really an adequate description of its function, as only during the actual handling of unprocessed film is absolute darkness required. The majority of the time the darkroom will be lit with coloured light, usually yellow to red, which will not affect photographic paper during its development.

Darkrooms come in all shapes and sizes, from cupboards and bathrooms to specially built rooms. For the individual who only requires to process up to a dozen prints at a time a bathroom would do, but for serious amateur or school use, then a permanent room has to be available.

Forced ventilation is a must for the darkroom because, as well as stale air, the evaporating chemicals are probably harmful and certainly quickly attack any metal objects. The atmosphere in any darkroom—even with good ventilation—is to some degree caustic, so keep a watchful eye on all equipment. Remove and store the enlarger lens outside if possible, or in a well-fitting drawer, and NEVER leave a camera inside.

An inexpensive electric fan working in a tunnel drawing air out, with a filtered opening in an opposite wall letting air in will give adequate ventilation.

Arrange the light switches inside the darkroom carefully, as it is very helpful to have a separate switch for ordinary white lighting for cleaning. Locate this in an almost inaccessible place. Vacuum clean darkrooms, never sweep them. If you have running water, where will it run to if your sink overflows?

The best darkrooms do not require a door. An opening with an S-bend light trap, if you have the room, is simple, and materials can never be ruined by people opening the door on you inadvertently. DARKROOMS SHOULD BE PAINTED A LIGHT COLOUR INSIDE—NOT, AS IS FREQUENTLY THOUGHT, BLACK. You need a reflective colour to enhance the coloured safelights so that you can see what you are doing.

ESSENTIALS

You can operate on either of two levels. For both you have to be able to see the developing print on photographic paper, and for this you need—

MINIMUM:

A safelight. Usually an orange/red unit which is free-standing or screwed to a wall. It is quite possible to make do with a hand torch pushed into a translucent, appropriately coloured, plastic beaker.

Two trays. Plastic, cheapest you can buy. Food storage boxes will do, one for developer, one for fixer.

Water. Running water is ideal, but a bucket will do to rinse the developed print before immersing in the fixer. Transfer the fixed print out of the darkroom if you have little room, and into normal light for washing in either running water, or soaking in a container of water with at least eight changes, both for one hour.

Chemicals. Photographic developer and fixer.

Photographic paper. Available in 10–100 sheets. Various kinds, see page 24. Cheapest is single weight, glossy usually, of normal (No. 2) contrast.

A means of timing the processes. Your illuminated clock/watch will suffice. Timing is not all that critical within, say, 30 seconds (plus or minus) during the developing, and you can leave the paper over the stipulated time in the fixer by a few minutes with no apparent damage. It is quite possible to process all the prints shown in this book, either Pinhole or 35 mm black and white, by this method.

Of course, if finance is available and the interest is there, then the production of quality prints becomes more certain with the purchase of the following—

BASIC EQUIPMENT IN A DARKROOM
HARDWARE

Three developing trays. Developer, stop bath, fixer. A further tray containing a clearing agent for chemically removing the fixer can be used, although the later resin-coated (RC) papers can do without this.

Two pairs print tongs for use in above.

One print washing tank or syphon standing in a sink. The syphon fits over the edge of a tray and is connected to running water. Its action is to flow water across the prints and drain from underneath in one motion.

One 60 second timer. This is used in timing exposure during print developing. It is an advantage to have a timer fitted between the power point and the enlarger.

One 60 minute timer, with alarm if possible. This is for timing the film developing process. It is also used to time film during the fixing process.

An enlarger. Good quality, because cheaper ones will not give the required even distribution of light on to the masking frame.

A masking frame or easel. This holds the photographic paper in place on the baseboard of the enlarger and frames the print to the required size. It is usually metal, but try to get hold of an all-plastic version.

A thermometer—0–50°C—Photographic.

One or more safelights, according to the size of your room.
NOTE: You will have to change the colour of your safelight when changing from ordinary black and white prints to graphic arts film (see page 67).

A litre measuring jug, plastic.

A plastic funnel.

Two contact printing frames. One clear, one for 35 mm film strips. Glass and plastic type ONLY.

Film developing tank.

A pair of scissors, and if you can afford it, a small guillotine for trimming photographic paper.

A number of plastic clips for hanging film to dry.

A car windscreen-wiper blade for wiping off excess

water after hanging, or RUBBER-bladed squeegee.

Towels. Change frequently to avoid contamination, or use paper towels.

Waste bucket. You will probably be throwing dripping wet, poor quality prints away so don't use a basket!

Chemicals.
Film developer.
Print developer.
You can buy a Universal developer which can be used for both.
Stop Bath. (If used)
Fixer. (Same for film and paper)
Clearing agent. (If used)
Make up chemicals as required and store in dark glass or plastic bottles. Refer to individual instructions supplied with chemicals.

USEFUL NON-ESSENTIALS
Film cassette opener (or use the edge of your scissors).

Separate light set-up for graphic arts film which can be switched on instead of photographic paper safelights.

A 0–60 second timer between the power source and the enlarger. You simply dial the required time, and activate by pressing a button.

Vacuum cleaner.

3 Introduction to Light-sensitive Materials

Photograms

Photograms are objects placed on a light-sensitive surface which interrupts the passage of light to varying degrees. Objects with parts not in direct contact curving away from the surface will show a gradual softening effect.

As an introduction to the properties of photographic paper, a sheet can be removed from the darkroom into direct light and an object, your hand will do, held flat against the light-sensitive side. The paper can be easily seen to discolour quite rapidly, while removing your hand after a few minutes will show a photogram very clearly. Leaving this further exposed will cause the image to eventually vanish. Some of the image can be preserved by immediate submersion in a fixing solution.

Experiments vary from the rather unimaginative scissors, feathers and leaves type to light refraction shown on this page.

All the examples were produced under an enlarger in a darkroom, but there is no reason why exposure to direct lighting, either globe or sunlight, would not produce similar results.

All the examples were produced on a hard (No. 3) grade contrast paper.

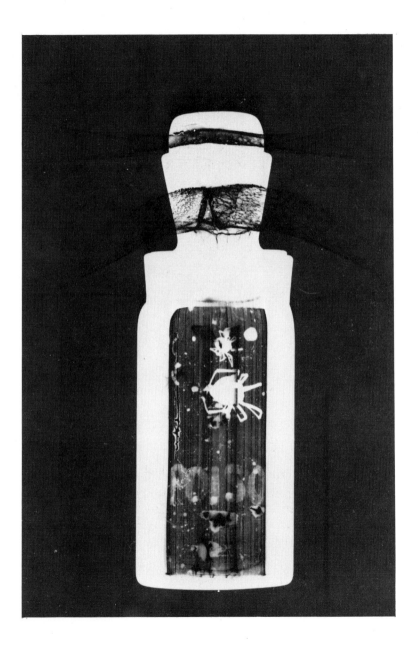

Spiders in a bottle:

Red Back or Black Widows in preservative. The bottle is clear glass placed on photographic paper. The interesting thing is the dense refracted light which is at a greater collective intensity than that of the direct enlarger light during exposure. The writing on the glass and the placing of the occupants were arranged to increase the interest in the resulting photogram.

Enlarger lens—f8.
Exposure—4 seconds.
Kodak Veribrom paper, Grade 3, glossy.
Dektol developer.
Kodak Indicator Stop Bath.
Ilford Hypam Rapid Fixer.

Lacewing:

Placed alive into carrier of enlarger between thin plastic sheeting (heat stencil type) which holds the insect firmly, but without damage. Insects treated this way are released unharmed. Take great care to avoid electrostatic dust.

Enlarger lens—f8.
Exposure—3 seconds.
Development as above.

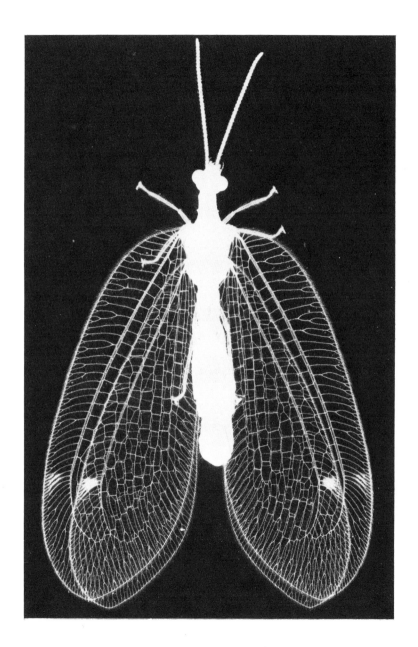

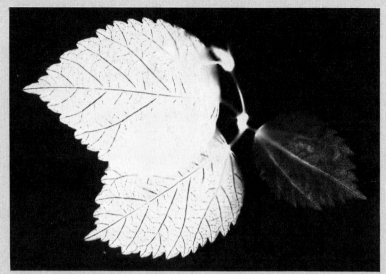

Leaves. Placed flat on paper under enlarger. 5 seconds exposure at f8.

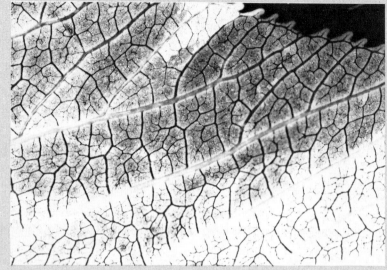

Section of Leaf. Placed in carrier of enlarger. 6 seconds, f2.

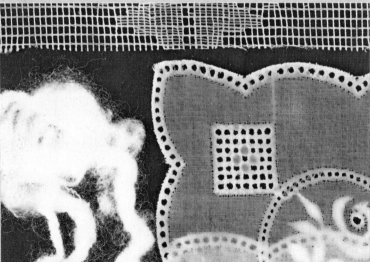

Material. On paper under enlarger. 5 seconds, f8.

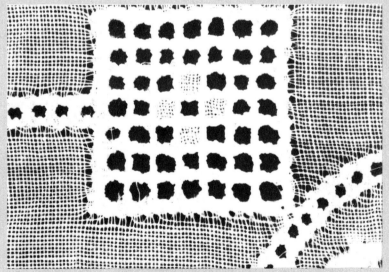

Same material in carrier. 4 seconds, f8.

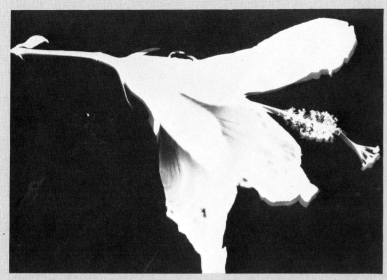

Flower. On paper under enlarger. 5 seconds, f8.

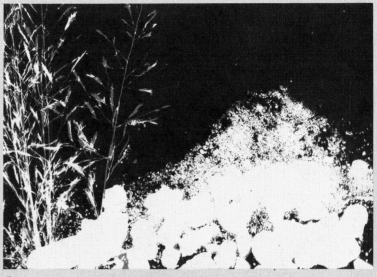

Dust, stones and grass. On paper under enlarger. 5 seconds, f8.

Newsprint in contract printer shows image of both sides. 4 seconds, f2.

Insect in resin. Placed flat on paper. 4 seconds, f8.

Working with Light-Sensitive Materials

4

Using Photographic Paper

The black and white photographic paper used throughout this book is sensitive to blue light, therefore we can work with it in a darkroom (see chapter 2) which is lit by a range of strategically placed yellow to red safelights. Keep these at least 1 metre away from the paper.

Apart from the convenience of having some light in the darkroom the main use of a safelight is in controlling the time in which the exposed paper is immersed in the developer. You have to see the latent image darkening on the surface of the paper and so be in a position to remove it when it has reached the required density.

You can purchase photographic paper of varying contrasts, surface textures, tones and weights, which adds to the interest.

Contrast is usually measured in numbers 1 to 6, ranging from purely soft tones to high contrast. For pinhole cameras or film printing a No. 2 (normal) grade is the best to start with.

THERE IS NO NEED TO USE FILM IN PINHOLE CAMERAS. PAPER IS FAR EASIER AND DOES NOT NEED TOTAL DARKNESS AT ANY STAGE, SO IS EASIER FOR BEGINNERS.

When printing, you can alter the paper to suit any variations, planned or otherwise, in the negatives. If you have a negative which shows a grey image with little difference between light and dark areas then you can compensate to some degree by choosing a higher than usual contrast paper, either No. 3 or 4. You can, of course, reverse the process to tone down the print if your negative is too contrasty.

For paper thickness the cheapest is single weight, usually glossy-surfaced. However, unless you have a photo-blotter or other print dryer, the prints will develop a substantial curl. You can, of course, leave them inside a book for a few days. Using a double weight paper will help, but better still are resin coated papers which not only dry flat but require much less cleaning. Their surfaces remain hard during all processing stages, eliminating scratching and dust absorption on drying.

Developing Photographic Paper

You need—

Paper developer	(Ilford Bromophen, Kodak Dektol, etc.).
Stop bath	
Fixer	Usually the same for film and paper
Water	Preferably running
2 print tongs	

FAILURE TO PROPERLY CLEANSE CHEMICALS OUT OF THE FINISHED PRINT WILL EVENTUALLY DISCOLOUR AND RUIN IT. IT IS A VERY COMMON FAULT. YOU CAN PURCHASE A CLEARING AGENT WHICH CUTS THE WASHING TIME CONSIDERABLY AND CHEMICALLY DE-ACTIVATES THE FIXER.

1. Mix the three chemicals and store in separate bottles (plastic will do) in a dark place.
2. You will need four working areas for developing. Work out a rotation, left to right or reverse, for all your movements in the darkroom and stick to it. Lay out your trays accordingly. Adjust the chemical solutions to the recommended temperature by adding warm or cold water on mixing. You can be a little outside the given temperatures

$(+-2°C)$ with no obvious effects on the image quality. Pour into trays.

3. Slide your exposed paper into the developer, face up. Agitate the developer by gently rocking the tray. The image will slowly appear and darken. Watch this closely until it reaches the required stage, usually 1–2 minutes, then remove, leaving it to drain for a few seconds.

NOTE Pinhole cameras

If the print appears quickly and has to be removed from the developer before it turns completely black, you have over-exposed it or the pinhole is too large. If it takes longer than two minutes to produce a reasonable image it is under-exposed or the pinhole is too small.

4. Slide the paper into the stop bath and leave for 10–15 seconds agitating during this time. Remove and drain for a few seconds. The stop bath will chemically de-activate the developer and keep the fixer cleaner as a result.

5. Slide the paper into the fixer face down, which will prevent under-fixing by floating to the surface. Leave for the recommended time, from 40 seconds for the rapid fixers, to 5–10 minutes in other fixers. Agitate frequently, keeping the prints apart as much as possible. You can leave the prints in the fixer over the stipulated time by a minute or two, but longer may start to bleach the image. After fixing, you can turn on the main white light.

6. Wash in gently flowing water for not less than 1 hour. There are three methods usually used—

 Slotting vertically into a tank washer

 Placing in a tray which has a flushing device fitted to its side

 At least ten changes of water of about 5 minutes each duration.

7. Dry by leaving on clean paper or towel in a dust-proof area. If there is dust present, cover with a soft towel, or better still, dry in a photo-blotter or electrically heated drying press.

 The resin-coated papers will dry in a far shorter time than ordinary bromide paper.

NOTES

Some of the chemicals can be re-used and re-bottled, so read the instructions.

One pair of tongs is for the developing tray only, and the other is for the fixer and stop bath trays. Do not allow the tongs to cross over. Even a small amount of fixer or stop bath will spoil the developer.

You can use your fingers instead of tongs if you must but rinse them well between operations.

The chemicals will stain material so wear an apron if you can, and use paper towels.

A clock is useful, but not really necessary. After a short time you will find that you can guess the times— they are not all that precise. The only really important point is that you wash the prints as thoroughly as possible (as step 6).

NOTES Printing from film negatives

Rather than guess at the length of exposure under the enlarger for each print, or which prints are suitable for further work, it is far better to place all your negatives into a contact printer. This is a hinged frame with a glass top which clips down on to a base and forces the negative into the closest possible contact with a sheet of photographic paper. Print by either exposing under the enlarger or turning on the main lights for

a fixed time. Under the enlarger, try 5 seconds, stopping the lens down to f4.5. Develop the resulting print. From this you will be able to estimate fairly accurately the times of exposure for each negative. There are contact printers for all widths of film and these can be used for contact printing of paper negatives from pinhole cameras.

Use a No. 2 grade paper, which will give a standard range of grey tones.

Keep the same f. stop for all printing, only altering the lengths of exposure.

As it is difficult to judge the exact time of development for a print, due to the difficulty in seeing the print properly under safelights, the procedure adopted for a quality print is as follows.

Making an Enlargement

There are three steps to adjust the enlarger to obtain the required print. The size of the print is governed by sliding the body of the enlarger up and down its column.

1. Open the lens fully.
2. Place your masking frame on the base of the enlarger. The frame is sometimes called an enlarging easel.
3. When you have the required size, turn the focusing knob until the picture sharpens. Move the lens either side of the focused picture to make sure.

You must now determine the correct exposure.

There are 3 ways to do this.

Text Exposure:

Cut a 2″ strip of photographic paper and put it into the masking frame, making sure it lies flat. Stop the lens down to f8 and switch the enlarger off. Place clock close to hand.

Place a piece of card over the paper.

When you switch on the enlarger you draw the card back across the surface in 5 to 7 equal stages of, say, 2 seconds each. Therefore the first part will be exposed for 14 seconds and the last for 2 seconds if you use 7 stages.

Develop the print and examine. Note which stage is the most acceptable and proceed with the full size print.

Print Scale:

Purchase a print scale. This is a plastic sheet, usually with a 10-stage ready-printed mask to cover up your test strip. It saves time and gives completely uniform results.

Enlarging Exposure Meter:

This is a fairly expensive piece of equipment, available from most photographic dealers. It measures negative density electronically and enables you to expose correctly without going through a test print stage.

Place the test strip across an area of some interest in your projected image.

Before placing the film in the carrier of the enlarger, wipe it with an impregnated material made to remove dust.

5

A Simple Pinhole Camera

The pinhole camera is simply a box with a hole in one end. It can be made from almost any box or tin, but a carefully made one will give better results.

A simple pinhole camera is a small darkened room made from black card. In fact any card will do providing the inside is painted a non-reflecting matt black. This prevents light bouncing off the insides spoiling the image on the rear wall which has the light sensitive surface attached to it.

Draw the dimensions of the camera carefully twice onto the card, making sure one is 2 mm larger or smaller than the other.

Cut out with scissors or hobby knife on a card or wood underlay.

Make the pinhole at this stage. (Refer to page 29.)

Placing a ruler along the dotted lines, fold up all four sides and glueing flaps. It will help if these flaps are held down with a ruler inside the box while glueing.

Glue up both boxes, making sure to position the glueing flaps on the inside of the smaller box and on the outside of the larger. This will ensure a close fit.

The larger box will be the front part of the camera and will have the pinhole in it.

The smaller box then becomes the rear part which contains the four pieces of angled tape to hold the photographic paper.

On completion, hold each part up to a strong light source and look for unwanted holes, blocking these up with black water-based paint or small pieces of black paper.

The box is square so all dimensions are the same.

Try between 8 to 10 cm for your first attempt.

Have the glueing flaps around 2 cm. Do NOT use contact adhesives as these might bond the two boxes together. Fold, then glue three of the sides first, followed by the fourth.

The pinhole:

The quality of the finished print will depend very largely upon the size and quality of the hole.

A pin or needle drawn through the card a few times will give acceptable results depending upon the thickness of the card, the thinner the better. Alternatively, you might try glueing in place a 2 cm square of aluminium foil over a smaller square cut in place of the pinhole. It is easier to make the hole before fitting.

Place foil on card and pierce through with a No. 10 needle halfway up its shaft. Unfortunately some foils tear rather than move away so examine closely and discard any that are less than perfect.

Aluminium foil is used because it is thin and light-proof, but if you have problems, gummed paper strip is a good substitute when blacked over. Wet the pin before inserting, and check for any stray light.

Inserting the photographic paper:

Refer to chapter 4 for suitable types. Insert in the darkroom. The safelights will be ON.

The easiest way to attach photographic paper to the back of the camera is to use either double-sided masking tape or tubes of masking, not gummed, paper tape, rolled from approximately 3 by 2 cm wide tape.

Rear wall of camera.

Photographic paper slips in behind these flaps.

Rolled tubes of sticky tape approximately 3 cm × 2 cm.

Press down firmly into the camera back in order to remove some of the 'tackiness' from where the paper will be attached, which will ensure that the tape remains in the camera and not pull away when you remove the paper for developing.

Handle photographic paper by its edges, as the natural oils on the surface of your fingers will prevent the developing processes from taking place.

Press down the photographic paper, with the light sensitive side facing towards you, onto the tape. Refer to page

Cut a master card from black card as a template for the photographic paper to avoid difficulties in the darkroom.

Photographic film can be used in place of the paper but it is far more sensitive to light and has to be loaded and developed in absolute darkness. For ease of handling purchase the thicker, sheet film. As with photographic paper there are a variety of types which react differently to light—find out about them.

Other methods of closing the shutter.

Close the camera, making sure that the front flap or SHUTTER as it can now be called, is pressed against the pinhole or APERTURE. Build as shown in the diagram, hand hold shut or place an elastic band around the camera.

Taking the picture:

The camera must be kept absolutely steady while the shutter is open. It cannot be hand-held but must be placed on a flat surface.

Hold the body of the camera with one hand and open the shutter with the other. If you are using the flap version, be sure it falls down under its own weight (bend frequently to achieve this) and hold it down with a finger. Keep the finger near the camera unless you wish to include it in the picture!

If you find it difficult to steady the camera, glue it on to a base of thick cardboard, which you can hold while taking the picture.

On a sunny day open the shutter for about 6 seconds for the first attempt.

One of five things will happen on developing the paper.

Result:	To correct:
1. The image is too light. i.e. under-exposed.	Leave shutter open longer or, only if you have to, enlarge the pinhole slightly.
2. The image is too dark i.e. over-exposed.	Close shutter earlier. If less than 3 seconds make another smaller hole.
3. The image is blurred or double-image occurs.	Hold steadier.
4. The image shows circular with a white edge. (You may like this, however.)	Enlarge the pinhole slightly and shorten the exposure time.
5. The image is acceptable.	

General Notes on Pinhole Cameras:

Most cameras are constructed out of stiff card but more durable ones can be made of thin ply, 3 mm (or ⅛'') thick, using fabric tape along the joins inside and out.

Providing that the pinhole is made as suggested, everything from 6 inches to infinity will be in focus or have a relatively sharp image. This is more accurately called depth of field.

The use of an enlarger is not necessary. For a larger size print simply construct a larger camera.

A small pinhole camera . . .

. . . and a large one!

If you wish to look at or show the image as it will appear on the rear of the camera, cut out a square and tape a piece of waxed paper across it. Some experimenting to find a paper that will work is necessary. The inside wrapping of some cereals is suitable but you will have to shield the faint image with a card surround if you wish to demonstrate it. The optimum size for sharpness of image with the normal grade of photographic paper would appear to be a box between 8 cm and 16 cm in depth. Larger boxes give their own unique images characterised by interesting grain and circular patterns forming.

As the depth of the box increases beyond 16 cm the pinhole will have to be increased in size to the point where a knitting needle is used with a 60 cm box. Too much stray light is now entering the box and spoiling the sharp image but interesting abstractions appear.

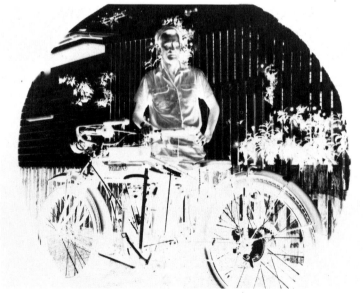

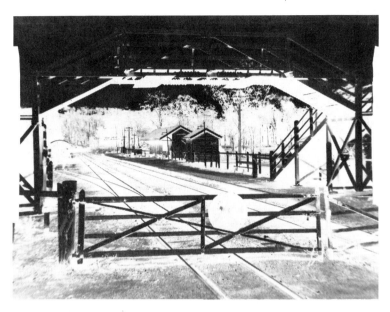

Contact Printing

The completely dry negative print is returned to the darkroom and, under safelights, an identical or slightly larger piece of photographic paper is prepared. This is laid down with its light sensitive side FACE UP and the original negative placed FACE DOWN on top of it.

CONTACT PRINTING.

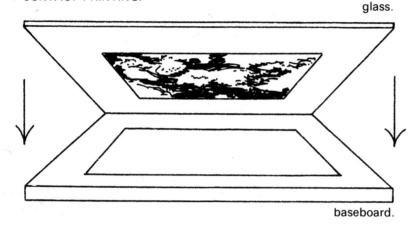

glass.

baseboard.

IN THE DARKROOM place photographic paper into the contact printing frame with the light sensitive side face up.
Place the paper negative face down on top and close the frame.
Expose to a 100 watt light bulb at a distance of approximately 3 ft.
Try 8 secs. Use a small piece of photo paper as a trial.

The two pieces of photographic paper are then placed into a contact printing frame for exposure to light.

With the frame tightly closed expose to light by either placing under your enlarger and turning cn the main lights, or taking the frame outside the darkroom.

Light will now pass through the negative print and effect the paper underneath. It should now be appreci-ated that light will not pass through the dark areas on the negative as easily as through the open or white areas and it is this that creates the positive print by reversing the negative. Open the contact printing frame, under safelight conditions, and develop the paper in the usual way.

It will also be appreciated that the length of exposure will vary according to both the density (darkness) of the negative image and the 'weight' or thickness of the negative paper. It follows then that single weight photographic paper will allow more light through and, as a consequence, more detail onto the final print. Film is contact printed the same way.

As there are so very many variations in photographic papers it is best to use small pieces in the printing frame at varying speeds until you become familiar with a particular type. As a rough guide, try 4 seconds under the enlarger at f2 aperture when using light-weight paper as the negative.

6

Adding a Lens to the Pinhole Camera

If you were surprised at the results of pinhole cameras then you will be astonished when you fit the simplest of lenses. If the word 'lens' bothers you then have a look at the accompanying photographs. The lens was removed from an inexpensive magnifying glass of the type used to magnify print and purchased from a stationery shop. A school science laboratory will have many types. Naturally, purchasing a better lens will give increasingly better results, but total camera cost should not be more than $4. The lens used measured 7 cm in diameter and has a focal length of 29 cm. Refer to notes on focal lengths, page 45.

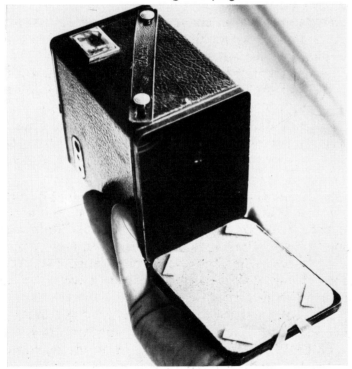

A Box Brownie camera adapted for photographic paper.

A useful way to compare a production camera with the one illustrated is to get hold of an old Box Brownie. Remove the interior and you have, minus the focusing device, an almost identical product. If you fit photographic paper into the Box Brownie instead of film then you can duplicate the action of your home-built camera without the complications of film processing in total darkness. Attach the paper on to a piece of cardboard fitted into the opening back of the camera as shown. On a bright day place the shutter on B speed, open and immediately release.

The results obtained from exposing directly onto photographic paper in a Box Brownie will often be better than the normal procedure of first exposing on film and then contact printing on photographic paper. The exposed paper in the camera will, of course, become a negative print on developing so you will need to reverse the image—black to white/white to black by contact printing in order to obtain a positive print.

An important feature of this type of camera is that because we have bypassed the use of film it is a complete process and there will be no unwanted marks on the print, such as dust spots and water stains.

All lenses which are not specially made for photography will not provide absolutely accurate images. The lens used in the examples shows distortion in the outer edges of the photographs. This effect, if not required, can be largely eliminated by restricting the size of the photographic paper to the centre of the image or by fitting a baffle with a hole cut in the centre as illustrated. The print then displays the characteristics of early photographs, as in the motorcycle print.

Remember to explore the range of contrasts and tones available in photographic papers to achieve a

satisfactory result.

A simple lens:

A piece of glass or plastic which has an accurately formed surface on either side is suitable. The surfaces of a simple lens can be either convex, one convex and one concave or one convex and one flat.

The old Box Brownie has a lens which is convex and concave similar to the very earliest lenses produced in the 16th century, known as the 'meniscus' lens (Greek. meniskos, a little moon) which were already in use in spectacles, telescopes, and microscopes. It is believed that Niépce fitted a meniscus lens to a camera obscura for his earliest photographs, making it the world's first lens.

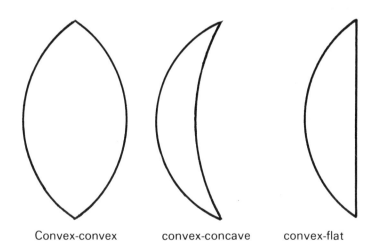

Convex-convex convex-concave convex-flat

The Simple Lens

Installing a lens:

Installing a lens into a pinhole camera will require

a few modifications of a fairly simple nature but the basic design of two closely fitting boxes remains the same.

You may be able to visualise the method of construction from the drawing and proceed using your own ideas but in case you find this difficult we will proceed step by step to the finished product. To do this the construction is divided up into three basic parts—

1. The rear box, which contains the light sensitive material.
2. The front box, which contains the lens.
3. The lens unit, including lens cap.

Construction:

Decide whether to construct the camera from thick card or thin plywood. Both work equally well but the ply version looks better and lasts indefinitely.

The depth of the camera will be governed by the focal length of the lens you have obtained. To find the focal length of your lens, see method on page .

The cardboard camera is made from heavy gauge packaging cardboard, cut with a heavy duty hobby knife and held together with packaging tape and P.V.A. glue.

The plywood camera is made from lightweight 3 ply, sawn with a fine-toothed panel saw. The three cut-outs are best made by repeated cuts with the knife mentioned above. This version is glued first with a quick drying epoxy resin, and the corners taped over later. Some of the internal parts could just as well be made with card instead of ply.

The illustration shows construction of a 3 mm ply camera. It has a lens with a focal length of 24 cm.

REMEMBER X to X measurement on the illustration will be the depth of focus of your particular lens.

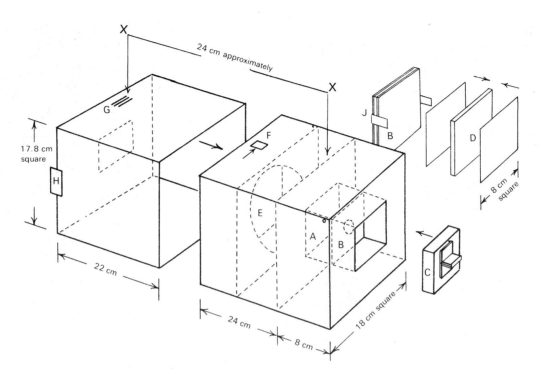

Key

A. *Interior wall containing light entry hole. For the diameter of the hole try 3 mm to start with. The lens supporting box passes THROUGH wall A. If card construction, attach with L shaped card strips.*

B. *Lens holder. Tight but adjustable fit in supporting box. With image appearing on waxed paper fitted temporarily to rear of camera, slide backwards and forwards by holding tabs (J). Focusing is achieved by adjustment of the lens and moving the rear part of the camera into the front part. Try for a sharp image at, say, 3 metres to infinity, mark with G through F. Pull slowly back and note that you are focusing on progressively nearer and nearer objects.*

C. *Lens cap. Remove to expose photographic paper or film.*

D. *Lens. Any well made glass lens will do—you can use a magnifying glass for example—but you will have to find the point of focus, and consequently the depth of your camera, by trial and error.*
If you know the FOCAL LENGTH of your lens then you can work out the distance between the lens and the rear of the camera. Refer to end of this chapter.

E. *Fit if you wish to obtain an image with a circular frame. If your lens has noticeable curvature distorting the edges of your print then this will hide the distortion.*

F and G. *See B.*

H. *Tabs of card to move rear of camera.*

J. *See B.*

Part 1 The rear box

Cut ply base 17 cm square and sand the edges smooth, taking care not to round them off.

Cut four identical sides 17.3 cm by 14 cm.

To prevent the box from glueing itself to the workbench, lay down a sheet of plastic.

1. Lay down the base and place a weight on it. Glue first side to base noting the 3 mm overlap. It is recommended that you first use Epoxy two-part glue then tape up with P.V.A. soaked fabric. Constantly check with a set-square.

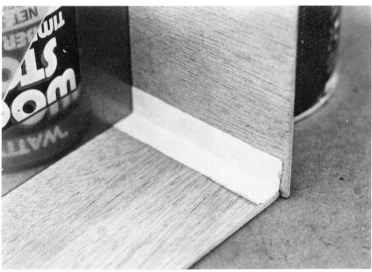

2. After two sides are firmly set to the base, tape up the side. Note the direction of the outer grain in the plywood. Add the other two sides to complete the rear box. Sand smooth and round outside corners slightly.

Cut a 6 cm square focusing hole in the rear, as in fig. 4.

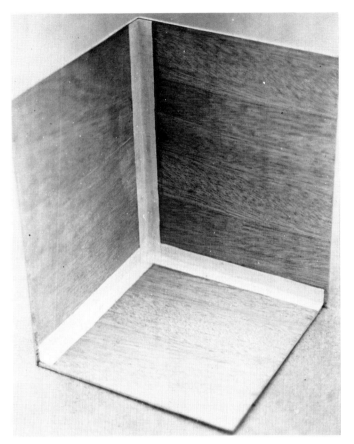

Part 2 The front box

3. Build another box around the first. Start by first joining two sides as shown, remembering to insert a thin sheet of plastic between the two boxes first. Before adding side 3 fit a 2 mm card spacer and a further thin plastic sheet between it and the inner box. Likewise, continue with side 4. This will give an adequate clearance all round of 1 mm when the boxes are fitted together

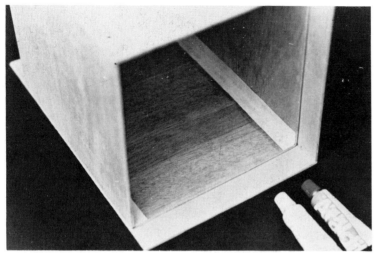

4. Rear view of the two boxes showing temporary focusing window fitted with tracing paper and the cutout for noting the focusing distances. Cut this hole with its centre 6 cm from the rear edge of the front box.

5. Cut wall B to fit tightly into front box. It should be 17 cm square. Find centre by drawing a line from corner as shown and drill a 1 cm hole.

Cut a 3 cm square thin black card and either use a paper punch or push a 2 or 3 mm nail through the centre (see note below), and trim off raised edges with a razor blade laid flat on the card. The neatness of this hole is most important as it will affect the quality of the print.

Glue card in place behind wall as shown.

NOTE

The hole diameter will vary according to the intensity of natural light that is present where you live. It would be better to have a 2 mm opening for constant bright conditions, and a 3 mm opening for duller climates or conditions. If you made a

'pocket' around the hole you could change the diameter by having a few interchangeable cards with various sized holes. A smaller hole will give a greater depth of field. (See page 45.)

6. Cut an 8 cm square hole in the centre of the front wall and lay down flat on plastic. Cut four sides, two of 7.4 cm and two of 8 cm. The 7.4 cm measurement is for 3 mm ply, so adjust for other widths.

 Glue in the wider sides first and form a box by inserting the others while the glue is drying. Use P.V.A. for this if the epoxy glue hardens too quickly.

Part 3 The lens holder

8. Build lens holder from card, 2 mm shown. Build up on the bottom layer to the top level of the lens, finally glueing down the remaining card to trap the lens. The holes in the card are 3 cm in this case, but a smaller one would probably do just as well because only the flatter centre part is used. This will give less distortion.

 Paint the inside edges of the circles black before glueing the unit together.

 The lens holder must be a fairly tight fit in the lens box. This is because the lens might have to be adjusted either forwards or backwards within the lens box to obtain the sharpest image. Start by placing the lens holder 2 cm in front of the hole in wall B. When the best position has been found, the lens holder is firmly glued in.

 Cut a 2 cm by 1 cm slot, 23 cm back from the front of the camera to serve as a calibration aid when focusing.

7. Seal up the corners with matt black paint and also the centre of wall B. Try completed lens box for fit as shown, but DO NOT GLUE.

9. Temporarily tape the front of the camera into place. This is so that the lens can be moved, as mentioned above. This front part can be either glued in or screwed down by four countersunk woodscrews onto 1 cm square rails to facilitate possible cleaning of the rear of the lens.

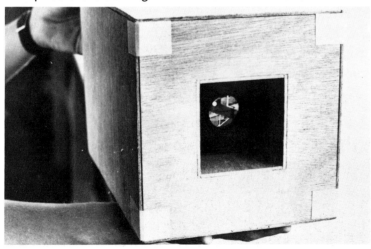

10. The lens cap
Thin black card fitted as shown around a ply square, approximately 7.7 cm, drilled at its centre and fitted with a cupboard knob which has a nut and bolt attachment. You will have to cut off most of the bolt and probably epoxy the nut on.
The depth of the card skirt is 2 cm. Do not use less. Push the lens cap into the box until it touches the lens holder before fitting light sensitive material in the camera.

11. The completed camera
Note the two pieces of material either side of the camera rear to pull the two pieces apart.
The version illustrated has interior tape in its outer box and if you attempt this take care to press the tape absolutely flat.
Paint the outside of the box with a water-resistant finish.
Paint the inside of the rear box matt black.
You could add a handle, feet and an aiming device.

Attach photographic paper as in the pinhole camera by using rolled tape.

If you fit graphic arts film into the camera do not use rolled tape as this reflects light back onto the film.

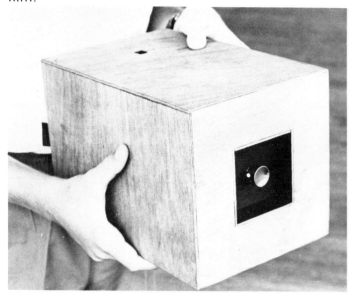

Focusing:

The easiest way to focus is to stand the camera in a dark doorway pointing out at a sunlit area. This will prevent too much light falling on the outside of the tracing paper and spoiling the image.

Place a series of objects 1 metre apart, away from the camera.

Pull the boxes apart until the nearest object is in sharp focus and note this in the window on top.

You will need to draw an arrow on one side of the window to line up with the number on the rear box.

Now focus on the next object and note that in the window, proceeding away from you until the camera reaches infinity.

It is useful to note up to six points of focus, from 1 to 2 m to infinity. Cover up the hole in the rear of the camera with ply and try the camera out to see if your calibrations are correct.

12. The camera is focused to 2 metres in this photograph.

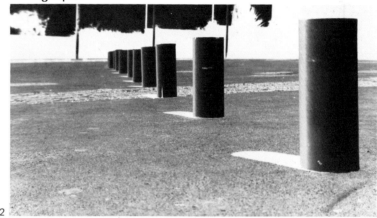

12

13

13. . . . and to infinity.

Exposure time 3 seconds.

You can simply calibrate the camera by marking on the top of the rear box—but the window looks better!

Possibilities:

Fit a 1 cm wood block underneath with a nut in the centre, threaded to fit the screw of a solid tripod. The placing of a wall, C in the drawing, with a hole in the centre will give a circular image and get rid of the worst effects of distortion due to the curvature of the lens. Refer to the drawing for measurements.

Focal Length

In a camera, the reflected light rays leave the subject at A.B.C.D., pass through the lens and reappear as a sharp image in reverse at a fixed distance behind it. A lens is manufactured to produce a sharp image at a precise distance from its optical centre. This distance is known as its focal length and is either measured in inches or mm.

If you purchase a quality lens for your camera (it may be designed for another purpose of course) then you will be told its focal length. You can then build your camera accordingly.

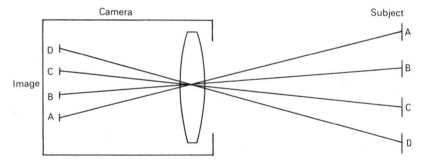

NOTES

1. To take advantage of the fact that you can build your camera to take large prints you need to buy a lens with a LONG focal length to give a large image. Conversely a short focal length lens will give a smaller image. In fact a long focal length will give a shorter depth of field while the shorter the focal length the deeper will be the depth of field.

2. The lens opening should be kept fairly small to compensate for narrow depth of field with long focal length lenses.

FOCAL LENGTH

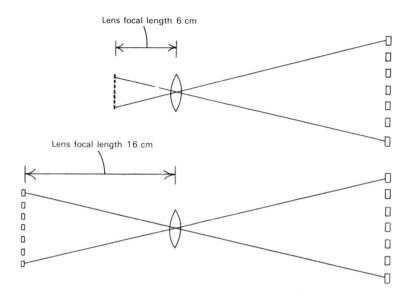

Lens focal length 6 cm

Lens focal length 16 cm

IF YOU DO NOT KNOW THE FOCAL LENGTH OF A LENS IT IS VERY QUICKLY FOUND BY THE FOLLOWING METHOD.

Place your lens on a printed page. Raising the lens towards you will magnify the print until it becomes blurred. The distance from page to lens just before blurring is its focal length. Measure it and build your camera so that it equals the distance from the lens to the film or photographic paper.

Depth of field:

The area in front of the camera which will be of acceptable sharpness on the print. Focus drops off both near and away from the point of focus.

Depth OF FIELD

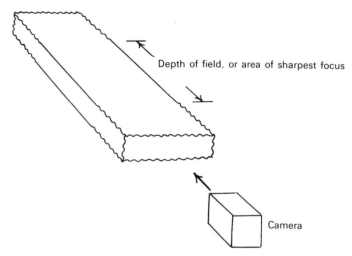

Depth of field, or area of sharpest focus

Camera

The depth of field is increased or decreased by—

1.	The size of the opening behind the lens.	Large opening- narrow depth of field Small opening- greater depth of field	Ref. Notes 2.
2.	The focal length of the lens.	Long focal length —narrow depth of field Short focal length —greater depth of field	Ref. Notes 1.

3. The further away the subject focused on gets, then so the depth of field increases.

Design for a wind-on attachment for the lens camera.

*To close camera
Large elastic bands will hold it shut.*

Zig-zag lines indicate thin black cloth light trap on all four sides.

*Spool is wooden with metal tube driven into top with metal strip cross-piece to engage key.
Smaller solid bar in bottom.
Spool rotates in this direction to wind on.*

Double sided tape for attaching role of photo paper.

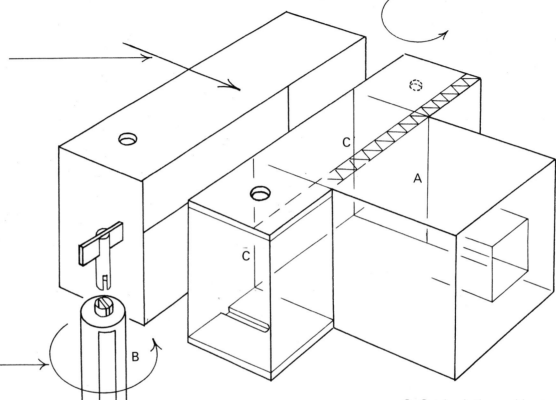

*Rotate spool B with key which pulls the wound paper off spool A.
With plain paper note how many turns of the key wind on one frame.
Cut the roll from the longest sides of a large sheet of photographic paper. Join if necessary.*

C. Cut back these sides to allow photo paper to pass and cover with thin cloth to prevent scratching.

A 360° Pinhole Camera

This version of the pinhole camera is designed to give an all-round picture from a central fixed position.

The overlapping of the images is produced by using a continuous strip of photographic paper or film around a central core, as shown, and exposing it through a series of pinholes in the outside circumference of the camera body.

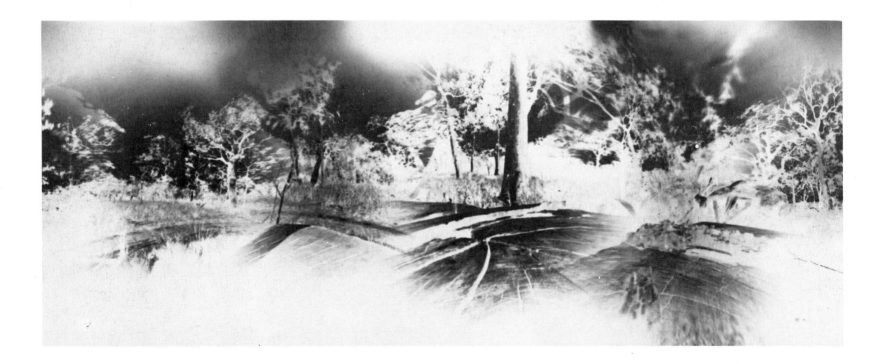

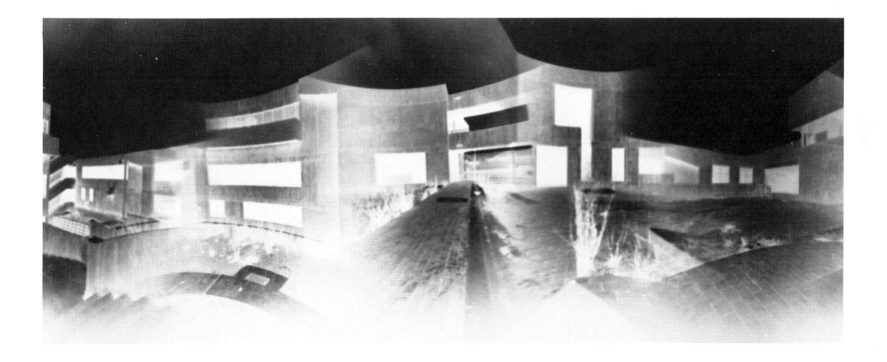

The exposures are taken one at a time by rotating the outside card drum which has an opening in it. The exposures are taken in sequence around the camera allowing the operator to remain out of the images.

Try 4 to 6 pinholes, depending upon the size of the camera and the distance from the hole to the paper. You can adjust the amount of overlap this way, and the holes can be made, covered up, and re-made as required.

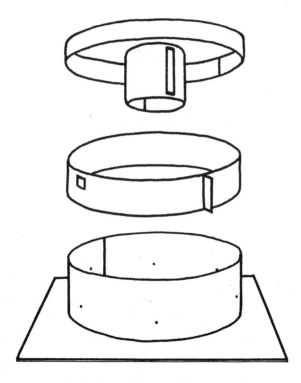

Glue down on to thick card folding edge inwards as shown. Make holes before glueing.

Lid has to be tight. Glue lip straight down onto top with P.V.A. Photographic paper is attached to central core by joining the ends onto double-sided tape.
Revolving shutter. Bend end back as a hold for turning.

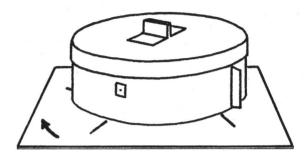

Mark base with lines to show position of pinholes and direction of travel.

The distance from the holes to the paper in the tree picture is 4.5 cm, and 5 cm in the buildings. The very small image is from a camera with an inner core circumference of 9 cm.

As with all multiple-image cameras, care should be taken to achieve constant diameter holes. Deliberate over and under exposing can be obtained by varying the length of exposure. Try 6 to 8 seconds on the larger camera to start with on a bright day.

If you fit the camera onto a tripod, try various angled shots.

The 360° camera can be constructed from two tins by glueing one to the floor of the other. Problems with making satisfactory holes in tin can be solved by cutting away a larger hole, filling across with black paper and making the pinhole in the usual manner. Line the interior with black paper.

Cut the window so that it will arrive level with the pinholes. The ring will have to fit below the level of the bottom edge of the lid.

To operate:

Instal photographic paper under safelight conditions as for previous box cameras.

Move away from the field of view as you proceed to expose around the camera.

Note that the circumference of the inner circle is the length of a standard size photographic paper, 25.4 cm.

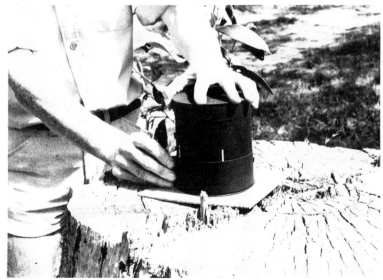

Using the 360° pinhole camera

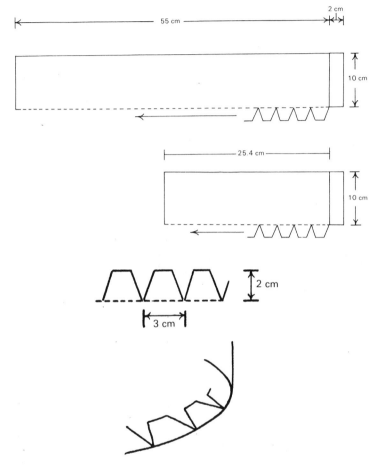

Construct from thick black card and cut with either scissors or knife. Make about six pinholes at this point equally spaced. While it is possible to butt join the edges of the card directly onto the base with modern adhesives, a more durable camera will result from a serrated edge being cut and folded inwards as shown in the second illustration. Measurements for the serrations have no need to be exact. Use 3 cm at the inside fold and 2 cm on the outside as shown. The 2 cm measurements refer to overlapping edges for glueing.

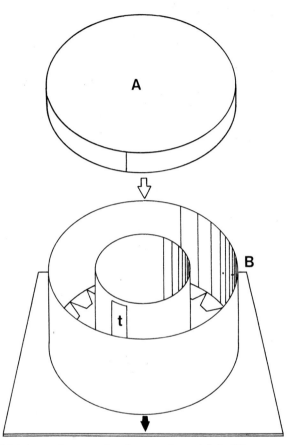

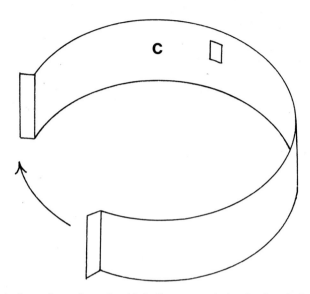

This is a ring of card which fits around the body of the camera and which slides around it, presenting each pinhole in turn for exposure. The glueing flap remains projecting outwards as a hand hold for turning. When fitting, try to have a free running, sliding fit.

Cut a thick base from packaging cardboard 28–30 cm square and find the centre by drawing from corner to corner. With a compass draw a number of circles on the base to serve as a guide for the two circles of card.

Face one of the pinholes towards a marker, an arrow in the illustration, to show where the starting point was, thereby avoiding double exposure.

The letter 't' refers to a strip of double sided masking tape onto which both ends of the photographic paper will stick. The lid 'A' must be a good fit and is constructed in the same way as the body of the camera. Remove it with a twisting movement.

8

Using Black and White Panchromatic Film

The term 35 mm refers to the width of the film in millimetres. 'Instamatic' or cartridge film is 35 mm in width.

Short lengths of film can be developed in a tray in total darkness. However, we are usually handling lengths of around 2 to 3 feet, so it is usual and convenient to develop film inside a lightproof tank specially made for the purpose.

Materials needed for developing film:

Developer	Various brands. Dilute.
Fixer	Purchase a rapid fix variety. Dilute.
Stop bath	Sometimes not used. Try with and without, examining the results carefully.
Developing tank	Various brands, Paterson, Kodak etc. You can buy tanks which take one or more films at a time. A two-film tank is useful.
Photographic thermometer	0–50°C, with clips.
Clear plastic litre jug	
Plastic or rubber hose	Approximately 1 metre in length to connect tank with water supply for washing.
Clips. Two per film	Commercially made or 'bulldog'. One to hang the film up with and the other to weigh the end down.

Windscreen wiper blade or rubber squeegee
You may wish to buy a non-staining detergent from a photographic dealer to add to your final wash, which prevents scum drying out on the film.

Developing your Film (Paterson Tank, but most others are the same)

1. In TOTAL darkness open the film container, unwrap the spool or break open the cassette, whichever film you are using.
2. Place the film into the developing tank as shown in the instructions with the tank. It is not easy to do straight away, so a few hints may be useful.

Lay out the parts of the tank in the same order always, (this goes for the rest of the darkroom).

35 mm and cartridge film is by far the easiest to load into a spiral. Cartridge film will have widely spaced holes on one side only. This may give problems with some spirals, so ease the film as far round the spiral as possible before winding on, and place your clean fingertips gently on the film to make sure that it is winding on.

With the Paterson tank, fit film on the spiral, trap the loose film gently against your chest and hold the hanging film straight downwards with an extended little finger. This technique is especially necessary with 127 and 620 film.

126 or 127 film is thinner than 35 mm and rolled tightly onto a thin metal spool. When the film is unwound to separate it from its paper backing it will sometimes twist and jam. Bend the end of the film back on itself or it will touch another part of the film, prevent chemical action, and spoil it during processing.

620 or Box Brownie film. A thin wide film which is difficult to thread into the spiral. It has the knack of fitting the first time or not at all. Use all the above techniques with it.

If possible, purchase a spiral which has a 'self loading' attachment, particularly if you intend working with a lot of 126 or 620 film.

When fitting the lid of a tank in the dark, screw on anti-clockwise a few turns until a 'clunk' is felt. Stop there and screw back clockwise. This is important with plastic to plastic lids as the thread tends to wear after a time.

Practise the loading techniques in room light with your eyes shut. If you get into trouble during loading, get assistance.

Develop sheet film as for roll film, but in trays.

3. Once the film is inside the developing tank and the lid fitted on tightly, the main lights can be turned on or the tank can be taken outside for developing.
4. Develop, following the instructions given with the particular product.
 The sequence will be—
 1. Check temperature of developer.
 2. Refer to chart to find length of development for your make of film.
 3. Measure correct amount of developer into clean jug.
 4. Pre-set clock.
 5. Pour developer into tank.
 6. Start clock.
 7. Agitate for some 20 seconds to remove trapped air bubbles.
 8. Fit cap, if there is one.

9. Invert or agitate spiral in the tank every minute until the time is up.
10. Empty tank. Refer to developer instructions as to whether to keep it or throw it away.
11. Either pour in stop bath or give the tank a quick rinse with water to remove excess developer.
12. Refer to chart for recommended fixing time.
13. Place 0–60 minute clock to hand. (0–60 seconds if using rapid fixer.)
14. Pour in fixer.
15. Start clock.
16. Agitate gently until time is up.
17. Empty tank. Keep the fixer. Check it regularly as it will weaken with each use and require full strength fixer added to it from time to time. Refer to instructions for this. Throw away if brown.
18. Connect to hose and flush gently in clean water for 30 minutes.
19. Hang film, preferably in a heated, filtered drying cabinet, if you are not in a darkroom or a dust-free area, otherwise dust will be deposited on to the film. Most damage is caused at this stage when the film gelatine is swollen and soft. Dust gets drawn in and cannot be removed.
20. Draw the rubber part of the wiper blade at 45° down each side of film twice.
21. When absolutely dry, cut into short lengths and store either in folded paper envelopes gelatine/plastic/gelatine or better still, place in negative storage wallets.

Faults in Processing Film

During developing:

If you either over or under-agitate the tank, small bubbles will adhere to the surface of the film preventing developer and/or fixer from working. Pale spots will show on the negative and reproduce as dark spots on the print. Tapping the tank gently on its flat bottom will help.

If the fixer has lost some of its strength the negatives will have a dull grey look. Put it back in the spiral and replace in the tank with fixer and examine it every few seconds. You can, of course, do this in daylight. Always hold film by its edges, as the cleanest fingers will leave marks on film due to the constant flow of oils to the surface of the skin.

Keep developer and fixer away from each other in well-marked bottles, preferably different coloured plastic ones, taking care to wash all parts of the tank after each chemical. A few drops of developer will not greatly harm the fixer providing its correct strength is maintained.

AN UNDER-WASHED FILM, AS WITH A PRINT, WILL TURN BROWN AND FADE WITH AGE.

During drying:

DUST IS THE FOREMOST ENEMY. All reasonable steps should be taken to eliminate it, especially during drying, because it will show up as white spots or blotches under the enlarger.

Reloading 35 mm film cassettes:

Film is very much cheaper if you reload your own cassettes. Purchase directly from the manufacturer if you can, to get the benefit of a discount. You can buy up to 30 metres supplied in a metal can. Either cut off lengths from this or load the film into a daylight bulk film loader. It is a good idea to load different lengths of film into marked cassettes, say 30 cm–1 metre. The shorter lengths are handy if fast processing is wanted, particularly after photographing on a copy stand where the negative is required as soon as possible. This is a frequent situation when working with graphic arts film.

Be careful not to either over- or under-load the cassettes. To find the correct required length IN THE DARK accurately, place tape at appropriate intervals along the front of your dry bench.

Re-usable 35 mm plastic cassettes can be purchased, while identical cassettes are available ready-loaded under brand names, so if you can't locate the former, look for the latter. If you can't find either then you can reload the standard metal cassette. Remember, some cassettes are much easier to load than others so try a few brands. The tops of most cassettes flip off easily with the flat of a pair of scissors, but be careful not to damage the soft aluminium lid too much. The film will be attached, in the case of metal cassettes, with adhesive strip, and with care this can be used again. Wind the replacement film around the core so that it leaves the outer light-trap in the correct way. It will not fit the camera otherwise. Perfect the technique of holding the core with one hand between thumb and middle finger with the film hanging down through that palm which keeps a light tension on it. Twist the core clockwise with your free hand taking care NOT to touch the face of the film with your fingers. The case will spring open slightly at the top of the light trap so this needs to be pinched in when refitting the

top. Twist the top clockwise when refitting.

Daylight bulk film loaders are available from photo dealers for easier loading outside the darkoom.

Loading 35 mm film onto a spool

9

Preparing your own Photographic Emulsion

Producing Lantern Slides

Reproductions of existing lantern slides can be made using the method described in this chapter, and, of course, damaged slides renewed by copying. In addition, you will be able to create new slides to make a collection, or add to an existing vintage collection.

Contact printing a glass negative onto another plate is how lantern slides of the nineteenth century were made. There is no need to restrict yourself to printing from your home-made negative. The most perfect glass slides will result from printing onto your plates from good quality 35 mm negatives made with a modern camera.

The most important point to remember is that you can produce perfect prints in terms of quality if you base your experiments around those suggested in this chapter.

Large glass plate used to make print on page 63

Making a Photographic Emulsion

The satisfaction of repeating early photographic efforts amply rewards the time spent in preparing the emulsion. If care is taken, the print will have the quality of the commercial product with a 'difference' which sets it apart. The emulsion can either be applied to paper or glass. However, while the preparation of glass plates might be time consuming, the negative will give a better contact print.

The Emulsion:
INGREDIENTS

Gelatin	Purchase a small box of ordinary food quality in powder form
Potassium bromide	18 g
Potassium iodide	0.5 g
*Silver Nitrate	20 g
Tap water	I have used both hard and soft water with no apparent difference. However, if you have problems with your emulsion, change the supply—remembering that the final washing takes place in quite a lot of water if you are thinking of using distilled water.

EQUIPMENT
2 plastic buckets
2 plastic food bowls, 1 litre size
1 plastic funnel
1 metal kitchen pan. Medium
1 graduated glass beaker, 500 ml
1 graduated glass graduate, 0–10 ml
2 × 1 metres of coarse screen fabric or equivalent,

see (e)

2 dozen clothes pegs

Thermometer 0–100°C. Make sure you can read it in the darkroom

1 glass or stainless steel rod or similar

Small quantity cotton wool

Quantity of glass plates, 2 mm thick

The normal darkroom will have the other equipment—clock, safelights etc.

METHOD

Make 3 solutions first, under normal lighting.

	Method	Utensils	Temp
Solution 1	Dissolve 20 g silver nitrate into 200 ml tap water. Filter out sediment through cotton wool in funnel.	1 plastic bowl 1 plastic funnel Cotton wool	40°C
Solution 2	Dissolve 5 g gelatin into 180 ml water. Then dissolve 18 g potassium bromide and 0.5 g potassium iodide into the gelatin /water solution.	1 glass beaker standing in pan of water	60°C
Solution 3	Dissolve 22 g gelatin into 120 ml water.	1 plastic bowl	40°C

The 3 solutions are now mixed together under paper SAFELIGHTS in a darkroom to produce the photographic emulsion as follows—

(a) Maintain solution 2 at 60°C and add solution 1 in small quantities over the next 5 minutes, stirring constantly.

Cover the pan (and beaker) with screen fabric, used later for filtering, and turn off heat.

Leave for 15 minutes in pan.

(b) Remove from pan and stir in solution 3, 50–55°C.

(c) The resulting emulsion should now be lowered in temperature to 10–12°C to allow setting by standing the beaker in cold running water. Use ice cubes if cold water is not available.

If the emulsion will not go below 12°C seal the beaker into a light-tight box or tin and place in a refrigerator for an hour or so.

SEAL BEAKER AND LEAVE IN DARKROOM OVERNIGHT FOR MAXIMUM CHEMICAL REACTION.

The next step requires the shredding of the emulsion into cold water to remove excess chemicals which have now formed (potassium nitrate, bromide and iodide). It will require a lot of clean, cold water.

(d) Double over the fabric and place onto CLEAN surface. Scrape set emulsion on to it. Gather up the four corners and allow the emulsion to form a 'ball'. Twist the ball with your other hand a turn or two to seal it off at the top.

Sink the ball into a bucket of cold water, and, still holding the corners firmly, twist the ball firmly. As you do this the emulsion will be forced through the fabric and will separate, falling to the bottom of the bucket as a mass.

Leave for 5 minutes to allow for settling and gently pour off the top layer of water until the emulsion

is reached.

Half fill the bucket with water (about 2 litres) and leave for a few minutes.

Repeat a further 4 times. You will notice the water clearing.

(e) Place a double layer of fabric (you can use some other synthetic material but wash it first to remove loose fibres) over the top of the other bucket and fix it there with the clothes pegs under the lip on the outside edge.

Press down the centre gently to form a hollow.

Wash out the glass beaker.

(f) Pour out the emulsion on to the fabric and leave to drain.

(g) Scrape the emulsion back into the glass beaker and place back into the pan of water as in (a) raising the temperature again to 60°C for 15 minutes.

The glass plates should have been washed in hot water and detergent, wiped clean and examined closely for grease and dust.

Lay on a flat surface before pouring the emulsion and CHECK THAT THEY ARE LEVEL. Have paper or thin card ready to pack up a side if they are not.

(h) Pour 6 ml (for a 16 × 16 cm plate) on to the centre of the plate and spread it with your finger in a circular movement. It will settle and dry evenly.

BE VERY CAREFUL THAT YOU ARE NOT SHEDING DUST OR FIBRES FROM YOUR CLOTHING WHILE YOU ARE DOING THIS. TURN OFF THE DARKROOM FAN AND LEAVE OFF UNTIL THE PLATES ARE DRY.

Do NOT attach the plates to the rear wall of the lens camera with double sided tape—you will not be able to release them.

Leave the emulsion to set in total darkness.

Develop and fix as for photographic paper.

Do not attempt to remove dust by wiping, this will only leave holes in the emulsion.

Fill any unwanted holes with black Indian ink or retouching solution.

Protect the emulsion on drying by painting on a proprietory coating, i.e. Kodak Film Lacquer, from your photographic dealer and, perhaps bond on a clear plate sealing the edges against mold as with ordinary 35 mm slides.

* You could try varying the amount of silver nitrate in the emulsion + − 2 g for a different reaction to light AFTER you are successful with the basic formula. As the liquid emulsion breaks down in about 10 days into a watery state, make only small quantities of emulsion. Adding more gelatin to watery emulsion will not be successful.

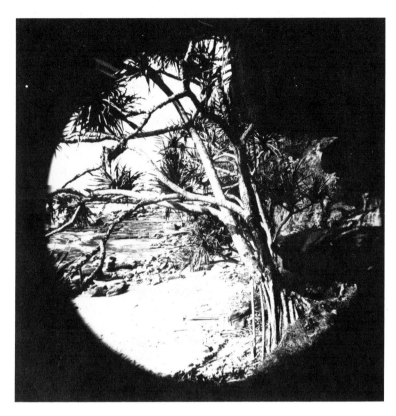

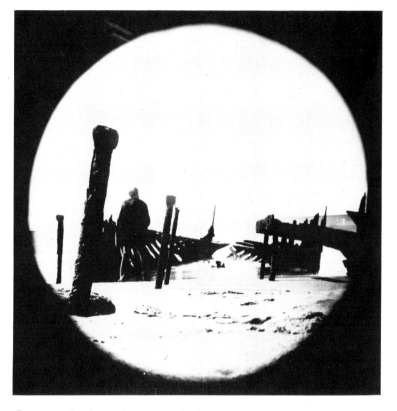

Moffatt Headland, Caloundra, Queensland. 10 seconds exposure.

Contact print from plate coated with home-made emulsion. 10 seconds exposure. If you look at the photograph carefully, you can see two of the more common faults, dust in the emulsion, caused here by leaving the darkroom fan on during drying, and small black pinholes made by wiping sand off the plate which had penetrated the camera.

The Wreck of the Dickie, Queensland. Contact print. 10 seconds exposure. Note surf.

10

Introduction to Graphic Arts Film

Graphic Arts Film

This is an extremely high contrast film with a slow orthochromatic emulsion. This means it is a sheet film which can be safely handled under its own specially filtered light so that we can see the image developing—as with photographic paper. When developed, it will only produce either dense black or clear areas.

The main users of graphic arts film, or 'Ortho' film, are printers who use Letterpress, Lithography, Gravure and Screen Printing in their work. It is in the last application we are interested.

The original artwork we produce will be known as line copy (this is the name used in the printing trade) and will preferably be solid black areas and lines against a white ground. We can, however, copy from a variety of tone or coloured subjects against backgrounds which are not completely white or clear, depending on what you consider acceptable. It may be that line copy which is not clear is what you have in mind for the final print.

We have to make a negative film of this line copy to expose onto the graphic arts film and this procedure is described in the following section, **35 mm Panchromatic Film to Graphic Arts Film**.

Graphic arts film is available in various sizes and thicknesses from the major photographic suppliers—Kodak, Agfa, Ilford etc. and will have a specific name, e.g. Kodak Kodalith ortho film, type 3, No. 2556 is used in this book.

These films are not cheap however, and you will have to purchase a minimum quantity—boxed. They do have a long shelf life with care and the finished film can be stored indefinitely. As with most things the more you purchase the cheaper they become and this is certainly the case with the developer. Obtain this in powder form. Complete instructions come with each quantity of graphic arts film.

I would suggest that you purchase large sheets and cut them down rather than holding several stock sizes.

You can also obtain Ortho paper, one type having a lightweight base for contact printing and designed to take drawn-on artwork in pencil, ink and opaque colour.

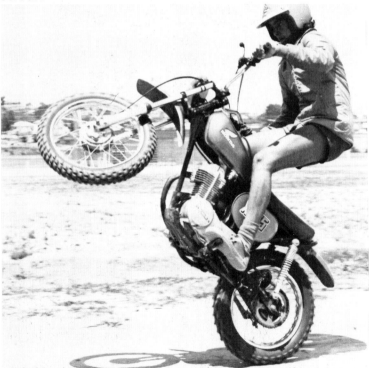

Normal photographic print of a motorcyclist made from a 35 mm negative.

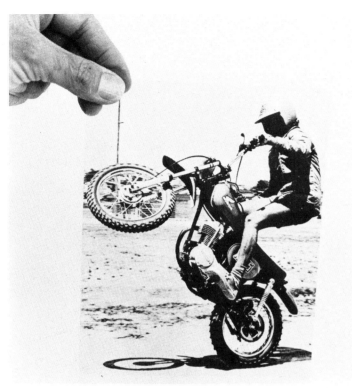

A 'print' from the same negative made on graphic arts film. Note the contrast and lack of middle tones.

35 mm Panchromatic Film to Graphic Arts Film

The procedure is the same as printing on photographic paper. There are three fairly minor differences:

1. The length of time that the graphic arts film is exposed to the image is less critical than photographic paper. Use a 5 cm square as a test piece. Try 8 seconds at f8 to start. Expose on the lighter side.
2. The developer is different and specific to the product. Agitate side to side and back and forth constantly during developing. The image should appear after 30 seconds, remaining in low contrast for a short while. There will then be a fairly rapid build-up of density in the exposed (black) areas. After approximately 1¾ minutes remove the film from the developer and examine for an adequate build-up of black. While doing this keep a close eye on the light areas which could eventually darken due to over-developing—this will happen within a few seconds so be prepared to sink it directly into fixer to save it.

 The developer exhausts itself more rapidly than the normal type, indicated by an extension of developing time, so be prepared to discard and replace.
3. The state of the film can be observed in the fixing tray. Fixing will clear the film of unexposed areas, leaving only the required image (black). Remove and wash as soon as this has been accomplished.

NOTE

Graphic arts film has a specific safelight. The normal safelight used for photographic paper will fog the film.

Decide which of your prints will be the most suitable for what you have in mind.

During the exposing of the 35 mm image onto the graphic arts film, unwanted areas or objects can be obliterated by careful interruption of the light by card cut to shape, or you may use your hand for less specific areas. Whatever you do, wash your hands thoroughly in clean water after developing, and dry them well if you intend proceeding with further prints. If you do a run of prints it is far better to expose a quantity of

film together, placing them aside, away from stray lens light, and developing them separately at the end. If you do this you will avoid accidentally spoiling unexposed film remaining in the box each time you remove a piece.

Basic Screen Printing

The object of this book is to look at light-sensitive materials, and when we use photographic techniques in screen printing we obviously need to have a working knowledge of the principles.

For screen printing, a suitable material, silk, nylon, cotton organdy or metal wire, is stretched underneath a wood or metal frame, dye or printing ink is poured across one end of the inside of the frame and forced down through the mesh in the material by a straight pull of a squeegee. A squeegee is usually a length of flat rubber or plastic held in a handle. (Refer to Chapter 12 illustrations 18, 19 and 20.)

Anything which prevents the ink from passing through the mesh is called a stencil, or blockout. The placing of this forms the printed pattern as required. Stencils can be single or combinations of—

Natural objects, leaves. Torn or cut paper, card. Wax crayon. Paint. Glue (NOT P.V.A.).

Hand-cut stencils, which can be either adhered to the mesh with water, solvents, or ironed on.

Photographic stencils, which become soft during processing and stick to the mesh as a result.

Direct application, filling the mesh with a sensitised solution which then acts as a photographic stencil.

The illustrations show a simple method of making a screen for most purposes. A screen used by professional screen printers would have to be made with greater control over tension and direction of fibres in the mesh.

The frame can be made as shown, or, better still, if the tools are available, fret the centres out of 7-ply, marine quality. This type of frame will never break or distort, as the more popular illustrated version may do after repeated use.

Before purchasing the screen material you will have to decide for what purpose you intend to use it. You have to purchase fabric with a particular 'mesh' for a particular ink or dye.

Type mesh* per inch	Application	Ink	Solvent
Grit Gauze	Surface print on material	Oil based. 'Banner' etc.	Mineral turps
83–150	Heat fixed in material by either placing in med/hot oven (instructions with dyes will give precise temp.) or applying as hot an iron as the fabric will take for a minute or two. Heat produces a chemical change in the dye.	Water based. 'Permaset'	Water until heat fixed
36–120	Printing on paper and card	Waterproof turps based. 'Ultrascreen' etc.	Mineral turps

83–110 Direct fill photostencil screens.

128–150 Transfer type (usually roll film) photostencil screens.
DO NOT USE WATER BASED INKS.
Refer to end of chapter for waterproofing these stencils.

*Multifilament mesh usual—use monofilament for finest detail when printing on paper.

Monofilament—regular sized strands with a smooth surface which are drawn out singly during manufacture. When these are woven the fabric mesh will have constant diameter 'holes'.
Requires less effort to clean, is more resistant to abrasives and therefore lasts longer.

Multifilament—irregular sized strands spun into single thread for weaving. When these threads are woven into fabric the mesh will not be a constant size. More difficult to clean and less resistant to abrasives. Use for coarse printing only.

NOTE
Nylon and Polyester monofilament can be purchased in red or yellow. This fabric is intended for use with the finer prints as it reduces the sideways movement of light during exposure so giving a cleaner edge.

Remember that silk is becoming a rarity in silk screen printing, but the name lingers on. Nylon and polyester fabrics have largely taken over.

Quite complex methods of mounting mesh onto screens can be found, certainly better-looking than the one illustrated, but it is as well to ask yourself how long is the mesh likely to be used and is it, therefore, worth the trouble. Professional screens are fitted in the same simple way, but a quick-drying epoxy glue is used instead of the staples. The staple-gun shown has a double spring hammer action. Do not use a cheap stapler which cannot fire into hardwood. Hammer any projecting staples flush with the wood.

(a) Cut the fabric oversize as shown and staple with a 'one up—one down' pattern. Place your first staple sideways and keep a slight tension on the other end while working towards it.
(b) Use clamp if possible, to pull the fabric evenly and repeat (a). You will find it helpful to have an assistant.

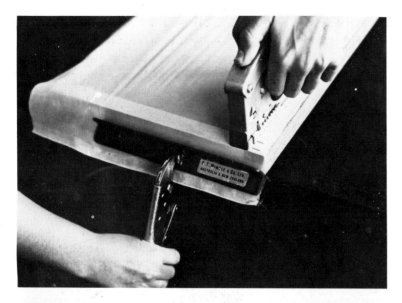

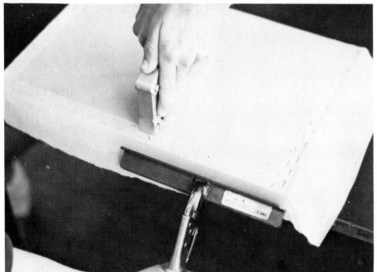

(c) Repeat (a) and (b).

(d) Tension. A question of experience with a particular fabric. Professional screens are prepared by using a method of measuring the tension. The simplest way for the amateur is to purchase your first screen from a supplier to the trade.

When the time comes to replace the fabric, the staples are fairly easily removed by using the corner of a broken kitchen knife to lift, and a pair of pliers to remove them.

After many changes of fabric, the wood surface may break down. Apart from turning the frame over, you can staple onto the outside edges of the frame. It will last for years, anyway.

If you intend to use wax, paint, glue or paper stencils, then you can use your screen immediately. However, any form of gelatine-based stencils, either hand-cut or photographic, or the presensi-

tised fill-mesh method, has to have a fabric surface which is absolutely clean and inert, but with enough of the original surface removed to provide a 'key'.

To do this, a fine abrasive powder is worked into the screen, gently rubbed with the flat of the hand and rinsed off with running water. Various brands of household cleaning powders are useful, but do not use them with natural fibres or the finer screen fabrics. Photographic stencils of the transfer type adhere best to natural fibres, silk in particular. For the successful adhering of photographic stencils, this must be followed by using a proprietory degreasing solvent as directed. These are available from all screen manufacturers.

Clean and de-grease after each printing session. Silk or organdy can be cleaned with a combination of warm water and detergent.

Nylon/terylene can be cleaned using a dilute (25%) solution of caustic soda left on the screen for 30 minutes, rinsed off, then followed by light rubbing with a kitchen cleaning powder.

Two home-made direct photo stencils:

These are the simplest that you can make yet will give results comparable to the manufactured product. They are simply, a base which fills the screen as a stencil, into which is mixed a sensitising solution of bichromate salts purchased as either potassium, sodium or ammonium bichromate.

We will use two bases, gelatin (the same readily-available food variety used to make the photographic emulsion in chapter 9) and polyvinyl alcohol (purchase in powder form from a wholesale chemist).

The formula refers to 'parts'. This means parts by weights. To obtain a bichromate solution mix with water at the rate of 28g crystals to 280ml hot water.

Two examples of direct stencil solutions used industrially which are readily available from screen printing suppliers. If you can purchase these in bulk, particularly the base, it will probably not be worthwhile making your own.

Formula 1

To 100 parts water at approximately 40°C, add 30 parts gelatin. Dissolve, add food colouring to see the stencil. To this solution add 3½ parts bichromate. Stir well and allow to cool.

Formula 2

To 100 parts water at approximately 40°C, add 10 parts polyvinyl alcohol. Dissolve. To this solution add 3 parts bichromate. Stir well and allow to cool.

NOTE

The water can be tap water. The author has used a variety of hard and soft with little difference, but change to distilled or rainwater if you continue to have problems with your stencils.

All the mixing can take place in subdued lighting as the solution only becomes light sensitive on drying.

The sensitised solution can be stored in a refrigerator for months providing it is in a dark brown bottle.

Store screens in a darkened area or darkroom BEFORE completely dry.

Coating screens:

There are one or two methods so it is simply a matter of individual preference. The only thing that matters is that you obtain an even coat of uniform thickness, which is not easy.

A useful method is—

Place screen on flat surface—base up. Pour solution along one end and draw it across the mesh with a piece of card or squeegee until it is evenly filled.

Lift and scrape across underneath to remove excess solution.

Leave to dry in the printing position in a darkened room as this will help to ensure that the mesh will not be on the surface of the stencil so spoiling the fine print detail. You can simply rest the frame on four tins to dry but any quantity will need a drying rack. When the coating is either nearly or completely dry squeegee a further coat onto the printing side. If the stencil is to have a lot of use you could add a third coat. If only a few prints are required then one coat is sufficient.

Exposure:

Use the same procedure as for photo stencils on page 83. Obviously, it is better to have a more reliable source of light than sunlight, and at a fixed distance from your screen. Some sources are carbon arc, mercury vapour, blacklight fluorescent, or photo-flood. The fluorescent tube lighting is very convenient if a number are built into a box with an opaque white plastic top, the screen being placed on this with the original positive in between. In any case specific instructions on exposure always accompany both indirect (or transfer) and direct photostencils, so follow their advice.

A good way to get to know your particular screen / emulsion / light-sensitivity is to stick masking tape (any opaque tape will do) across a portion of the sensitised screen in 2 cm rows six in number. Turn on the light source and peel off the strips at intervals of, say, one minute. If, for example, you have a carbon arc lamp of 50 amp, place 1–1¼ metres from the screen. There are no set rules, every printer has to get to know his materials by experience.

Washing out:

No hardener is needed but care should be taken to wet the screen as soon as possible to prevent further

hardening by direct light. Wash out with cold water, sprayed on. Use warm water if it proves stubborn.

The emulsion will not be easy to remove as it is usually removed with the entire fabric, new fabric being used for the next stencil.

Extending the life of water-based stencils:

The screen printing trade use a few ways to prolong the life of both their direct and indirect stencils and to permit their use with water-based dyes and inks which would otherwise break them down. Find out from your manufacturer which of his stencils tend to resist water the most, and make absolutely sure that you follow the instructions accurately.

You can apply a coating to both sides of the prepared screen. These coatings range from products specific to your stencil, or the use of ordinary varnish. The method of application is usually the same, the coating applied to both sides with the clean-cut edge of a piece of card or squeegee followed by careful opening up of the clear areas with thinners. The printing trade uses a suction machine to perform this function.

A more expensive but probably better way is to lay the screen down onto newspaper and spray a thin coating of hobby or touch-up varnish onto the stencil. The thinned nature of this will usually mean that it will readily clear from the open stencil areas by being absorbed into the newsprint.

12

The Screen Print:
from Copy to Finished Product

Producing the Original Positive for Copy

Below are three examples of the most widely used types.

1. Drawing with Indian ink on either clear plastic sheet or, as illustrated, on tracing paper. Use draughtsman quality, not greaseproof, if possible. Drawn with brush and Rotring pen.

NOTE

YOU CAN PROCEED DIRECTLY TO THE LIGHT SENSITIVE SCREEN WITH THIS METHOD USING A CONTACT PRINTING FRAME (Chapters 4 and 5) AND BYPASSING GRAPHIC ARTS FILM.

Letraset and hand-drawn horse transferred to graphic arts film

Drawing in Indian ink on tracing paper

2. Adhesive letters, Letraset, plus hand-drawn horse with graphic arts film print. Refer to Chapter 10.

3. Multi paste-up.
 Graphic arts film contact print on photographic paper at top.
 3 photographed figures.
 1 hand drawn ball.
 Letraset bottom line.
 Goal and figure outlines drawn onto final graphic arts film print.
 A line which showed under the heading scratched out.
 Refer to Chapter 10 for transfer to graphic arts film.

season 1976

Multi paste-up

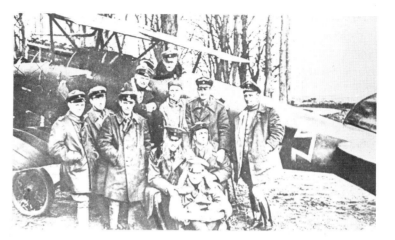

THE PROGRESSION FROM ORIGINAL ARTICLE TO MULTICOLOURED PRINT IN THREE STAGES

STAGE 1. Photo to Graphic Arts Film

1. The original to be copied. This, as previously mentioned, can be anything from a 3-dimensional object to an original photograph. For example, combinations of rocks, machinery, plants, magazine illustrations and original photographs.

2. Magazine photograph on copy stand ready to be photographed on black and white film by a good quality 35 mm camera. Providing a good camera is used, there is no real need to use a copy stand except where the available light is poor and a shutter speed of less than 1/60 second has to be used.

If 3-dimensional objects are to be copied, then the available light has to be bright, allowing a higher f. stop and consequently a greater depth of field. Store all negatives in a storage envelope.

3. After processing the film, a print is made. This can be any size, which allows enough required detail to be present, as a re-photographing process follows after which a decision on the final print size can be made. It makes things easier if the print is enlarged on to a grade 3 photographic paper which has a slightly higher than usual contrast. The resin-coated papers are ideal for this as it is difficult to damage the surface, wet or dry.

4 and 5.

This is the stage where the decision is made on the colour separation, or which parts of the photograph are to be separately printed and in what colours. For clarity, a two-part colour print will be followed through, although multiple-colour prints follow exactly the same principles. The print is covered with thin cellophane or plastic sheet and held firmly with paper clips or pinned to a board. Care must be taken to keep the plastic absolutely clean and free from fingerprints as these will deposit a greasy film no matter how well-washed, and cause the ink to run back. Support your drawing hand on a piece of clean paper to avoid contact with the plastic. The thin plastic sheets which are a part of transparency thermal copying machines are ideal. The Rotring series of plunger drawing pens with their extra-black ink are by far the most reliable method of drawing on plastic. An etching ink is also available which bonds to the surface of plastic. When drawing, remember that subsequent over-prints can, if required, cover up slightly ragged edges and that you should, in any case, arrange your drawings so that subsequent colours over-print ALL edges. To make this possible, it is usual to start with the lightest colour and finish with the darkest.

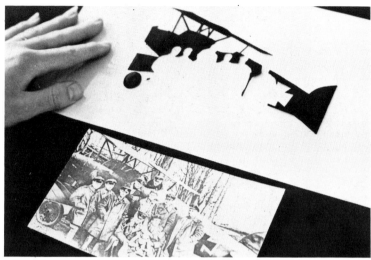

6. Place each resulting part on the copy stand and re-photograph on to 35 mm black and white film separately. The resulting processed negatives are shown.

7. The 35 mm negatives are placed into the enlarger and printed to the final screen print size on to graphic arts film. FOR PRODUCING GRADED TONES OF ONE COLOUR EXPOSE ONTO GRAPHIC ARTS FILM WHICH HAS A DOT PATTERN IN-BUILT. An example of this material would be Kodak Kodalith AUTOSCREEN Ortho Film No 2563.

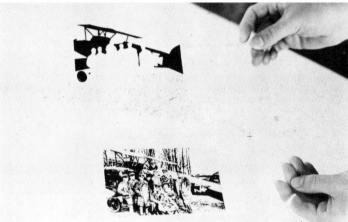

8. When completely dry, the registration crosses can be drawn on. You could have drawn the crosses

on to the original enlarged photograph and as a result transferred them photographically on to the graphic arts film, following this by simply tracing over on second or subsequent films, one for each colour. Any areas which are not dark enough can now be touched up with a Rotring pen. Likewise, unwanted black markings can be scraped off with a sharp blade. Make sure you work on the dull side of the graphic arts film.

STAGE 2. Transferring the Image to the Screen

9. WORK OUT OF DIRECT SUNLIGHT.

The screen will be on hand and prepared as in chapter 11. Of the two types of light-sensitive surfaces for stencilling which are available, the plastic-backed version which is supplied in a roll is the easiest for general use and is referred to in the subsequent procedure. Cut the film, allowing at least 3cm outside the nearest point on the illustration and registration marks.

RETURN ROLL IMMEDIATELY INTO ITS TUBE.

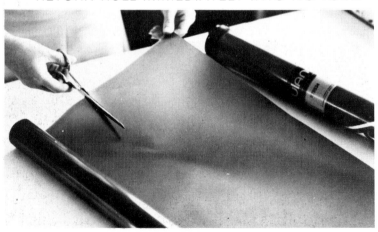

10 and 11

Without wasting any time, place the cut piece of film underneath the printed graphic arts film in the position shown.

There are a few variations to this procedure, but the following is a cheap and reasonably reliable method for ordinary use. The basic requirement is that the two films must be in perfect contact with each other preventing sideways infiltration of ultra-violet light, so spoiling an edge. Industry uses a vacuum machine to overcome this.

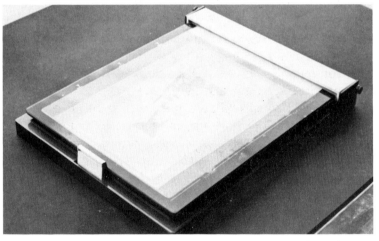

If fairly small prints are required, then the photographic contact printer as shown on page 34, is ideal. For larger prints, separate pieces of glass, thin black foam or paper and thin hardboard cut to identical sizes can be used. Grasp the 5-part unit firmly on either side and, placing it across your knee, apply slight downwards pressure with your hands. This flexing maintains a reasonably good contact within.

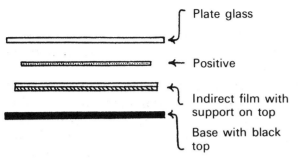

Plate glass

Positive

Indirect film with support on top

Base with black top

Angle the films directly at the sun, and expose as follows.

Bright sun—1 to 1½ minutes. Remember that even on a dull day there is sufficient actinic, or chemically-active light penetrating the cloud cover, so as a suggestion try a small piece of film exposed for over 5 minutes. Develop and modify the time according to the results. If a steady source of ultra-violet light is available then the element of 'hit or miss', as with the sun, is eliminated. For size and output refer to the individual manufacturers notes supplied with the stencil film.

NOTE

The exposed film should be developed and washed out as soon as possible.

12. You will, prior to stage 9, have prepared the hardening solution in a covered plastic tray or bowl. Put in enough hardener to cover the film about 1–1½ cm in depth. Most instructions require a greater depth than this, but this is costly and unnecessary. The temperature for this solution should be between 18-24°C. It will not work below 18°C.

Make sure that your film is not larger than the tray—it is easily done!

Place the exposed film, dull side up, in the hardener and rock the tray from all angles for approximately 2 to 3 minutes. Refer to instructions with the product.

NOTES on the hardener

The hardening solution is a dilution of hydrogen peroxide, H_2O_2, which can be either purchased with the stencil film or made up very cheaply. Purchase 100% volume H_2O_2 direct from the drug house and dilute as follows:

Add 2 parts distilled water to 1 part 20-volume strength hydrogen peroxide. This will be a 2% solution. If necessary, ask your chemist for help.

BE VERY CAREFUL OF H_2O_2. IT IS VERY CORROSIVE AND SHOULD ON NO ACCOUNT BE PLACED WITHIN REACH OF CHILDREN. In schools it should be handled in the laboratory with caution.

Store diluted liquid in a dark jar with the minimum of air space and in a cool place. Alternatively, if a short run of film is all that is required, then a chemist will sell you the diluted form, usually very near to correct dilution.

Diluted H_2O_2 is fairly harmless, but it is still a POISON and will bleach clothes.

The hardened film can be safely handled out of the liquid and onto the sheet glass for washing. Wash your hands afterwards.

The H_2O_2 reacts strongly to air and can rapidly lose its useful content. Throw away at the end of the day or when 3 or 4 pieces of film have passed through it. Do not attempt to store after use, as a foul expanding gas is given off.

13. This step requires warm water to be projected onto the now soft emulsion side of the film, so the water should be prepared and to hand immediately following step 12. Do not allow the water temperature to rise above 40°C.

(a) The best method is to lightly spray the emulsion surface with a diffuser nozzle fitted to a hose and on to a hot and cold mixer tap.

(b) The next best is most easily available to the amateur, and used throughout this book. That is to simply pour the warm water from a teapot or kettle, letting the flow fall from a couple of feet above the film.

The object is to remove completely all the emulsion which has been covered up by the black areas on the graphic arts film as this has remained soft and will dissolve. A sheet of plate glass leaning against a window and draining directly down into a sink is the most convenient base to use.

Look very carefully at the cleared areas to make perfectly sure that no emulsion is left. A thin film of transparent emulsion is easily left undetected in the finer areas of your film (which can now be called a STENCIL) and ruin your print.

Pour cold water over the stencil to harden it off a little and leave to drain for a minute or two.

NOTE

The finished stencil must remain near to its original colour as it was when unrolled.

If it has been under-exposed or not hardened sufficiently, the stencil will be pale in colour and probably too thin to use.

14. The screen will have been prepared for use and damped with water. You can do this by holding under the tap and leaving to drain for approximately 5 minutes in a dust-free atmosphere. Place the stencil, emulsion side up, on to a firm, raised surface which ideally should fit inside the frame of the screen. A piece of hardboard with a single piece of paper on it to prevent the plastic sticking to it by vacuum is sufficient.

15. Have ready some cut pieces of cheap absorbent paper. *Do not use newsprint*. Place as shown and press lightly across the surface of the screen. Some dye will be absorbed into the paper. This is normal, but BE CAREFUL. THE MORE COLOUR (WHICH IS THE EMULSION) YOU HAVE ON YOUR ABSORBENT PAPER, THE LESS WILL BE LEFT ON THE SCREEN AS THE STENCIL. When no white areas, or air pockets, remain, put up the screen to dry vertically and out of direct sunlight, as this might cause the plastic backing to buckle and possibly damage the drying emulsion. You can blow warm or cold air on to the screen to speed up the drying process.

16. When COMPLETELY dry, (the inside of the screen should not feel cool to the cheek) insert fingernail under a corner and gently lift and peel back.

NOTES

If the stencil has been cut too large and covers the frame, that area will take a long time to dry, and even then will probably not stick, due to the staples. Continue peeling until the fabric is reached, when usually a point of adherence will be found.

If areas of stencil come away from the screen, then you have either not prepared the screen properly or used too coarse a mesh for fine detail. Photograph 17 shows pale dots on the stencil. This is glue and has been used to block out pin hole breaks present at stage 7 that went uncorrected.

STAGE 3. Printing

17. Mask off the open areas of the screen as shown, using a combination of water solvent, gummed paper and ordinary paper. Alternatively, paper and glue can be used, making sure that the glue will readily dissolve off the screen during cleaning. Do not use P.V.A. glue. Wallpaper paste is ideal and cheap. Leave some space, at least 3 cm, between the edges of the masking and the cleared areas of the stencil.

The reason for this is that there will be a slight build-up of ink during screening due to the step created at the join of the stencil and the outer masking. This would create a surge of ink spoiling the print.

Mask the front and back of the screen to prevent any ink that is away from the actual stencil drying while printing is taking place.

The simplest way of masking is to cut a hole in the paper to fit over the stencil, gumming down the inner and outer edges securely.

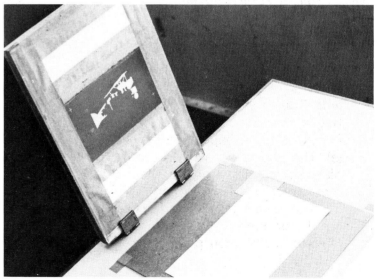

18. In the set-up shown, removable clamps are used and recommended. Screwed to a table, they can be removed quickly. Use a build-up of firm material (card, hardboard) taped to the table to bring the screen flush with the printing paper.

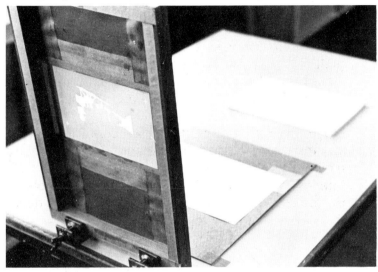

The most difficult part of multicolour printing is lining up each colour perfectly one on top of the other, so that the 1000th print is identical to the first. This is called:

Registration:

For printing on paper, we rely on 3 things—

(a) That the screen will drop down on to the same place every time. Tighten all screws and bolts and seat the screen firmly at the back of the clamps.

(b) That paper of a uniform size is used throughout the printing. If you cannot cut your own accurately enough, then purchase ready-cut stock and CHECK IT.

(c) Slightly raised tape guides on two or more corners. The guides should not be higher than the printing paper.

For printing on material which is too bulky to use with the registration methods described, try the following procedure:

Pin or staple a sheet of clear plastic, PVC or similar, to one edge of the printing table. For the first and subsequent prints pull the sheet across and print onto it. Allow it to dry. Raise the screen and, lifting the plastic, place the material to be printed underneath it. Slide the material around to register with the print on the plastic. Lift away the plastic without disturbing the material. Drop down the screen and print.

NOTE

Make a mark on the free end of the plastic to correspond with a mark on the table. Register this before each print.

You are now ready for printing.

The series of illustrations showing the printing are not the simplest method of achieving a standard print. For example, the screen could be placed sideways into the clamps and the squeegee drawn across in one movement. However, the approach shown was chosen to illustrate a further technique which is commonly used, that is, creating a slightly raised, or striped pattern, in the printed ink. Slightly differing tones can be achieved as a result, and this can provide a rather more interesting texture than a straight pull and will differ more with each print. Unfortunately, this is not apparent in the reproduction, as the print chosen was small, and photography tends to flatten.

19. Shows layout of equipment for tidy operation. LOCATE YOUR INKS, SQUEEGEES AND KNIVES ON A SEPARATE AREA TO THAT OF THE PRINTING AREA. Place or stand in receptacles if you wish. Keep the handles of your squeegee and knife absolutely free from ink, stopping the printing to wipe them down and starting again if necessary. ANY INK NOT INSIDE THE SCREEN ON THE PRINTING AREA WILL ALMOST CERTAINLY END UP WHERE IT SHOULD NOT.

Rub your hands around themselves from time to time, any hidden traces of ink will then show up. Have an adequate drying area ready.

REMEMBER: (Chapter 11) You have to use mineral inks with these stencils and wash out with mineral turps. Water dissolves the stencil. It is possible to purchase from your supplier solutions which will render the transfer stencil waterproof for short runs of around 100 with water-based inks before it breaks down. The solution is coated on to both sides of the screen and washed out of the open areas on drying. Some will inevitably remain in the finer areas of the mesh so it is only to be recommended for fairly coarse printing.

20. Take the knife and ink over to the printing area and run a line of sufficient quantity of ink along one end of the screen. Try to keep ink away from the frame if possible, as this will be a fairly difficult area to clean.

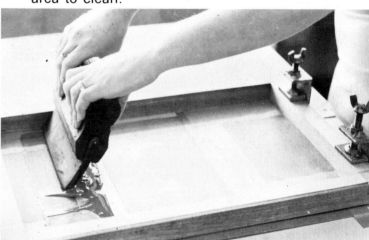

21 and 22

With the blade at the angle shown, pull firmly towards you. Depending on the density of your ink, you may require to return the stroke back up the screen. Reverse the squeegee to do this. This is sometimes referred to as 'levelling off' and will fill in any areas which the first pull might have missed, particularly against the edge from which

the blade pulls away. Some faults that may arise:

(a) The return stroke is needed to fill in all the details but too much ink is then deposited. Use a smaller mesh or you could leave the lid off the ink can for a while!

(b) The blade is not sharp, allowing too much ink through.

(c) The mesh itself is dragging along with the squeegee. As a temporary measure, insert cut strips of card between the mesh and the frame on all four sides. Clean the screen before you attempt this. This will tighten the mesh.

If you have an assistant, then he can remove and replace the printed paper, leaving the filled squeegee with you. If you haven't, then return the squeegee to the preparation area, which of course should be immediately to hand in this case. If, for

any unforeseen reason, you have to leave the printing area for a moment, then pull a thick layer of ink over the stencil to prevent drying. Don't leave it for more than a minute.

23 and 24

Lift the frame fairly sharply. The vacuum bond between paper and base frequently leaves the paper behind. If not, peel off from a corner. Treat the actual surface of the stencil with care if you attempt to clean it.

Any pin-holes that develop (possibly by pressing too hard with the squeegee, or too soft a base) can be covered over with small, thin pieces of paper with the minimum of glue in its centre. The screen can then be used immediately.

The next colour:

There are two ways to achieve correct registration with the first printed colour.

Either, place a print of the preceding colour into its registration tapes and carefully lay the prepared stencil film down on it with the gelatin facing up.

Slide the film until it matches the first print EXACTLY.

Fit a cleaned screen into the clamps and lower onto the film. Refer to part 14 of this chapter for the adhering process.

Or, place the next prepared screen in the clamps. Remove the previous guide tapes.

Attach two pieces of paper to the top and side of the printed paper. The paper should be long enough to project from under the frame when lowered.

Lower the screen onto the paper.

Holding the two pieces of projecting paper, slide the print around until the registration marks line up.

Lift the screen very carefully, leaving the print in position.

Mark the corners and tape as before.

Lower the screen and re-check registration. If out of alignment, slacken off the screen wing-nuts and line up the stencil on the print. Re-tighten and re-check.

25. Print the next colour.

Continually monitor the registration and adjust as in 22.

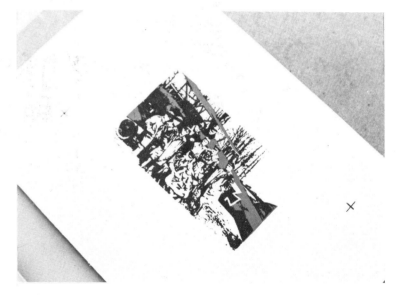

There it is. You have been introduced to printmaking in its simplest form, and now you can progress to other methods perhaps more suitable to your needs.

The emphasis has been on the practical side of achieving a craftsman-like standard of work. Now you have mastered the basics, the creative possibilities are limitless.

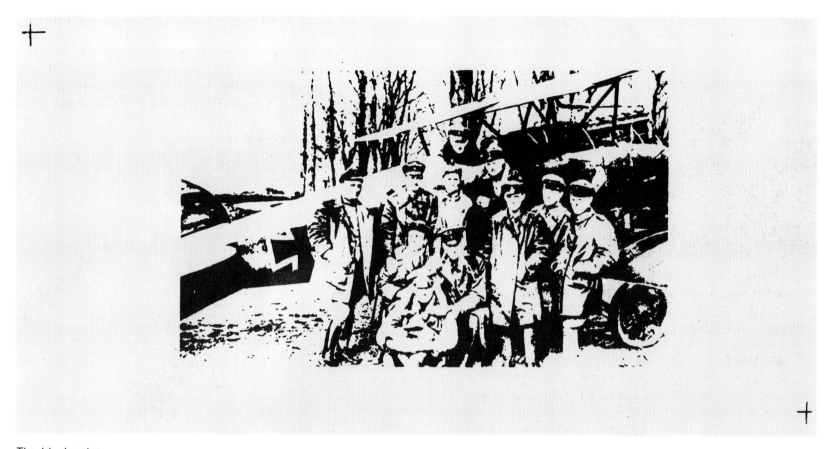

The black print

The second colour

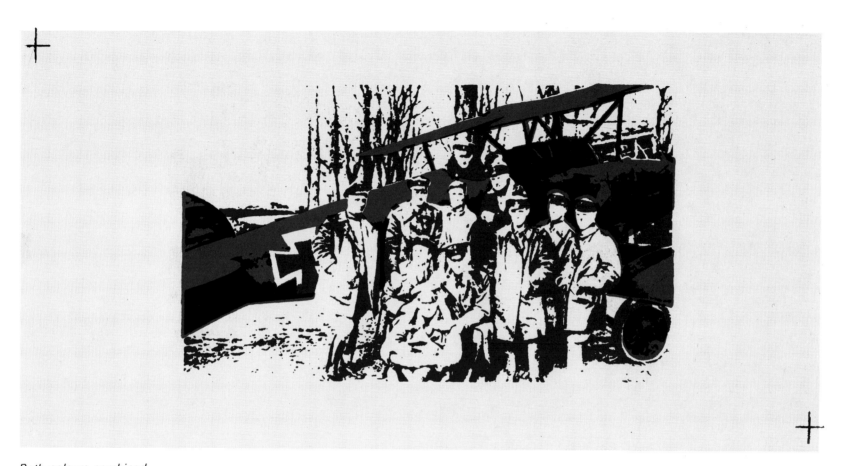

Both colours combined

Glossary

Terms in *italics* are defined elsewhere in this glossary.

acetic acid The acid used in diluted form for *stop bath* which halts or neutralizes the action of *developer* in the processing of *films* and *prints*.

agitation The technique of keeping the processing solutions moving continuously over surfaces of *film* and paper during immersion periods.

aperture The *lens* opening that lets light into the *camera* during *exposure*. Usually regulated on modern *cameras*, the different sizes expressed as *f-stops*.

camera From the Latin for 'room', a light-tight box with a *lens* and a *shutter* which admits light rays to form an image on light sensitive material.

cartridge A roll-*film* carrier, sometimes called *cassette*, (particularly for 35mm *film*) which encloses the light-sensitive material.

cassette See *cartridge*.

contact print A *print* made by sandwiching a *negative* and a sheet of photographic paper *emulsion* sides together and by *exposing* the paper to light through the *negative*.

depth of field The area extending in front of and behind the point of sharpest *focus* throughout which the image appears acceptably sharp.

developer A chemical solution that acts on the silver in a light-sensitive material affected by light, changing it to black metallic silver, making the latent image visible.

emulsion A coating of *gelatin* which contains *silver* salts that makes *film* and paper light-sensitive.

enlarger An apparatus for projecting light through a *negative* onto light-sensitive material to make an image larger than the *negative*.

exposure The effect of light on light-sensitive material, usually measured as a length of time.

film A sheet or strip of thin transparent material coated on one side with light-sensitive *emulsion* for recording an image through *exposure* in a *camera*.

fixer A solution which renders a photographic image stable by desensitizing the *emulsion*. It dissolves the silver remaining in the image that has not been affected by the *developer*.

focal The distance from the *lens* to the plane of *focus* where the light rays form an image.

focus The point inside a *camera* where light rays form a sharp image of the subject in front of the camera. To focus is to adjust the camera for this result.

f-stop See *aperture*.

gelatin A jellylike substance used to bind *silver* salts in light-sensitive *emulsions*.

hardener A chemical, such as potassium or chrome alum used in *processing* to toughen the photographic *emulsion* after it has been *processed*. In this book, a solution of hydrogen peroxide is used for hardening

photographic stencils for screen *printing*.

infinity In photography, the area furthest from the *camera* in which objects are seen by the *lens* in sharp *focus*.

lens A solid, shaped piece of transparent material, or group of pieces, which collect and modify light rays reflected from a subject to produce an image of that subject on the plane of *focus*.

mesh Cloth stretched over a wooden frame, made from various materials, on which stencils are fixed, in the screen printing *process*.

negative A *developed* photographic image on which the tones have been reversed from light to dark and dark to light. The image on transparent *film* from which a *print* is made.

panchromatic Sensitive to all the colours in the visible spectrum.

pinhole camera A *camera* whose *aperture* is not a *lens* but a small hole.

positive A photographic image whose tones correspond to those in the original subject. Opposite to *negative*.

print The photographic image in its final *positive* state, usually produced from a *negative*.

safelight A darkroom light with a colour and intensity not likely to affect a specific light-sensitive material during processing.

shutter A mechanical, or hand operated, device for controlling the length of *exposure*.

silver A necessary ingredient in light-sensitive emulsions, which is dissolved in nitric acid to form silver nitrate.

stop bath See *acetic acid*.

test print A *print* exposed in sections for different lengths of time to help determine the correct exposure for the particular combination of material being used.

viewfinder A device on a *camera* for sighting and framing the image to be *photographed*.

Index